Your PERFECT

Home-Based Studio

A Guide for

Designers and

Other Creative

Professionals

POPPY EVANS

NORTH LIGHT BOOKS
CINCINNATI, OHIO

WWW.HOWDESIGN.COM

658.02274I
EVA

Visit our Web site at www.howdesign.com for more resources for graphic designers.

05 04 03 02 01 5 4 3 2 1

Library of Congress Cataloging-in-Publication Data

Evans, Poppy.
 Your perfect home-based studio : a guide for designers and other creative professionals/Poppy Evans.
 p. cm.
 Includes bibliographical references and index.
 ISBN 1-58180-132-7 (pbk. : alk.paper)
 1. Commercial art—United States—Management. 2. Graphic arts—United States—Management.
 3. Home-based businesses—United States—Management. 4. Designers—United States—Interviews.
 I. Title.
NC1001 .E94 2001 00-052518
741.6'068-dc21 CIP

Editor: Kim Agricola
Designer: Wendy Dunning
Layout artist: Sandy Kent
Production coordinator: Sara Dumford

Dedication

To all my students, who will probably work out of their homes at some point in their careers.

Acknowledgments

I would like to thank all of the creative professionals who agreed to be featured in this book and allowed me to interview them. Their personal insights have enriched this book immeasurably. I would also like to thank Linda Hwang, who managed the editing of this book, and Kim Agricola, its editor. Finally, I would like to thank Lynn Haller for offering me the opportunity to author this book. It's extremely gratifying to be able to share what I've learned in setting up my home business with those who are just starting out.

About the Author

Poppy Evans is a freelance graphic designer and writer who has been working from her Park Hills, Kentucky, home since 1991. Prior to forming her own business, she served as managing editor for *HOW* magazine and art director for *Screen Printing* and *The American Music Teacher* magazines. In addition to this book, she has authored eight titles, and she is a frequent contributor to many design magazines. She is also on the faculty of the Art Academy of Cincinnati, where she teaches in the communication arts program.

POPPY EVANS

GRAPHIC DESIGNER

DESIGN JOURNALIST

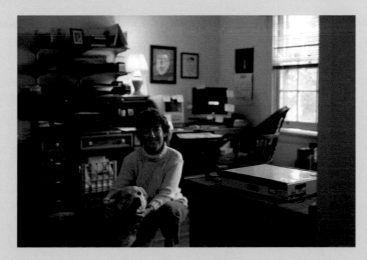

Poppy Evans and her assistant, Sunshine, in her home studio.

table of contents

Introduction

In the late 1980s, when personal computers began to impact our culture, many visionaries predicted that large-scale digital communication and commerce were far behind. They said that in a matter of ten years or so, America would become a nation of cottage industries—independent publishers and entrepreneurs working out of their homes, selling and delivering information, goods and services via the computer and other electronic means.

So here we are in the new millennium, witnessing the influence of e-commerce and the Internet and the actualization of these predictions.

It's been estimated that at the time of this writing approximately one-third—and possibly even one-half—of all American workers are engaged in full- or part-time work as self-employed or salaried individuals working out of their homes.

Home-based businesses are even more common among graphic arts professionals. Designers and illustrators have traditionally freelanced out of their homes to make extra money while employed full-time elsewhere or make ends meet in between salaried positions. The reality is that practically every creative professional in the graphic arts industry has worked or will find themselves working from home at some point in their career.

It's clearly time for a book of this nature—a how-to guide that will help creative professionals figure out what they need to do to set up shop in their homes. This book contains a lot of advice and practical tips on how to get the best deals on equipment and furniture, set up and run a small business and write off your home studio on your tax return as a business expense. There's also a lot of information on getting legal and professional advice and staying in compliance with federal and local tax and zoning regulations.

Although this book offers a lot of useful information, there is no cookie-cutter approach to setting up a home studio. From working out of my home for nine years and knowing other creative professionals who do the same, I've learned that everyone's home studio and work schedule is as unique as the way they live. To give you an idea of how others have fared in the same situation, this book includes profiles of seventeen successful home-based businesses, ranging from Web design to all kinds of graphic design and illustration. These firms include husband-and-wife teams, single individuals and parents. They represent a broad geographic range, as well as different venues, ranging from rural to urban.

Whether you're working from a cabin in rural Maine or an apartment in Los Angeles, whether your situation is permanent or temporary, this book will give you the guidance you need to set up studio space and make a success of working from your home.

1

✳ Tired of getting up every day at 7:00 A.M. and battling traffic on your way to work? Maybe your current work environment is full of distractions. Or perhaps your current job isn't providing the creative fulfillment you're looking for. Whatever the reason, you've chosen this book because you're thinking about working at home or already making a go of it.

This chapter will introduce you to the fundamentals of working at home, including equipment and work habits necessary for a successful home-based business.

HOW WILL
THIS WORK?

The Advantages

You've probably already thought of many advantages of working at home. To start, let's take stock of what they are.

✳ **You will save money.** You won't pay for transportation to and from work, including gas and parking if you're used to driving. You won't pay rent for a separate office. You'll probably also spend less on business clothing and dry cleaning.

✳ **You will save time.** Your commute to work will be reduced to the amount of time it takes you to walk from the breakfast table to your studio.

✳ **It's convenient.** Because your studio is part of your living environment, you can start working as soon as you roll out of bed or even work in the middle of the night if you choose to.

✳ **You can dress as you wish.** Keep in mind, though, that you'll be seen by couriers and others making pickups and deliveries at your home.

✳ **You can set your own hours.** Instead of working from nine to five, you can work from twelve to eight. You can take a three-hour lunch break, or you can work around the clock if you're really intent on finishing a project.

✳ **You can combine parenting with work.** You can work while your kids are napping or preoccupied.

✳ **You will have tax advantages.** If you're a homeowner, you can write off a portion of your home expenses as business expenses when you file your income taxes. If you rent, you can write off a portion of your rent and utility bills. (You'll find more information on this in chapter eight.)

How Well Are You Suited to Working on Your Own?

You also need to be realistic about making this situation work for you. If you're thinking about working at home, you need to take stock of your capabilities, personality and work habits. These are some of the attributes you need to have—or cultivate—to make your home-based business a success:

* **Experience.** You need to have enough experience to do all of the work involved in a project from beginning to end, including every production phase. When you're on your own, you won't be able to ask questions of co-workers.

* **Clerical skills.** You'll need to do clerical and administrative tasks, such as filing paperwork and making photocopies, as well as basic bookkeeping, such as keeping track of expenses and income. You'll also be pricing your services and billing clients.

* **Marketing skills.** You'll have to market your work to others, sell your concepts to a client and communicate your personal vision to those you will be working with.

* **Discipline.** A self-starter who is disciplined enough to get the job done from beginning to end can work alone. No one will be there to "crack the whip" if you slack off. You'll need to set goals and meet deadlines on current projects while simultaneously securing opportunities for future work.

* **Organizational skills.** You need to be good at organizing your time and your work environment. If you're used to depending on someone else in your office to keep you organized, you'll need to learn to do this for yourself when you're working at home. This means setting priorities to allow juggling several projects at once while balancing administrative tasks with the workload on hand. You'll also need to set up a work area and a system that will allow you to keep track of projects, as well as the correspondence and paperwork involved.

* **Well-Being.** Good health, emotional stability and the fortitude to get the job done even when you're not feeling well, are important to working independently. Unlike a salaried job where sick days are automatically paid for, sick days are lost time and money if you establish your own business. Even if you work from your home on a contractual basis with your former employer, you'll be obligated to meet deadlines and other business commitments no matter how you feel.

* **Contentment.** You should have a low need for status and a realistic view of the world. You should want to do this to make money doing something you enjoy and do well—not to become the envy of all of your friends. ───────

Avoid Bad Habits

When you're working at home you need to cultivate enough self-discipline to avoid distractions and other bad habits that can affect your ability to put in a good day's work. Here are some temptations that are easy to succumb to, but should be avoided:

* Sleeping late
* Chatting on the phone
* Watching TV
* Web surfing or online chatting
* Drinking alcohol while working
* Snacking too often
* Never showering or dressing for the day
* Procrastinating

How Well Is Your Home Suited to Your Business?

➤ Your home is probably the least expensive place for you to work, but in its present state, it will fall short of meeting your business needs if it lacks some basic requirements. The following questions will help you evaluate how your home will work as a business location and whether or not improvements need to be made.

✳ **Does your home provide the space you need for your business?** Those who have successfully worked from their homes will tell you that a separate space for your studio is a must. Working on your kitchen counter may allow you to get started, but staying organized and working efficiently in an area used for another purpose won't work for the long haul. You need to have a separate room, or at a minimum a sixteen-square-foot (1.5 m²) area set up as work space within another room.

✳ **Do you have adequate wiring for electronic equipment?** Computers, fax machines and other office equipment often require more outlets and electrical current than many (particularly older) homes are equipped to handle. If you own your home, you may need to invest in an upgrade of your current wiring. If you're in an apartment, inadequate wiring may limit your ability to install what you need.

✳ **Can you install additional phone lines?** A computer modem, fax machine and an extra phone line to field more than one call at a time are important to ensuring your clients and others are able to get through to you when they need to. If you rent, this may be a problem.

✳ **Are you able to receive deliveries from couriers and have visitors?** Do you live in a safe area that has adequate parking? If your neighborhood will alienate clients, schedule all of your business meetings at their office or another convenient location.

✳ **Do you need to be close to your clients, suppliers or others you work with?** In this age of doing business electronically, it's probably not important to be able to run a job to someone's doorstep the minute it's done. But if you live in a remote area, you may have a hard time getting the services and supplies you need in a timely manner.

✳ **Will others in your household be affected?** Be sure to consult with your spouse, roommate(s) or others involved in your living arrangement before you make plans to set up a work space in your home. It's pretty obvious that you would need others' approval to claim a room as your office, but remember to consider other changes in their lives, such as installing an answering machine with your business message on it. This arrangement may not be acceptable to others receiving calls on the same line.

Temporary, Permanent or Indefinite?

Many things can motivate a creative professional to work from home. Although each person's reasons are as unique as that individual, it's possible to categorize home studio situations as temporary, permanent or indefinite.

A temporary situation should involve minimal output of time and money. A permanent situation requires a long-term investment. An indefinite situation combines the best of both: minimal output with the flexibility for future expansion. To determine where you stand, see which of the following scenarios best describes your reason for working at home:

✳ **Scenario A.** Although you ultimately want a salaried position, you decide that freelancing will help you earn money while determining where your next full-time position will be.

✳ **Scenario B.** You're no longer happy with your current employer, and you feel that freelancing out of your home will allow you to determine if enough business is there for you to be successfully self-employed.

✳ **Scenario C.** You've negotiated an opportunity with your employer to do from your home what you normally did in-house.

✳ **Scenario D.** You're tired of working in a nine-to-five situation or for your current employer. You want to establish your own business and feel working out of your home is the best way to accomplish this.

Although each of these situations involves working at home, each has a different set of needs.

Which Scenario Describes You?

Scenario A: Temporary

This is typical of recent graduates and other newcomers to the field.

Good investments:
 ✳ computer
 ✳ scanner
 ✳ printer (a low-end model will do)
 ✳ software (only what you need to get started)
 ✳ answering machine and fax
 ✳ call waiting

Unnecessary investments:
 ✳ additional phone line, voice mail or new furniture

Produce your business materials, such as letterhead and business cards, on your studio printer.

You'll probably want to structure your business as a sole proprietorship (more on this in chapter two).

Scenario B: Indefinite

This requires minimal investment, but with consideration for the possibility of growth. With this foresight, you'll be better prepared if your home studio turns into a permanent business. Spend more now for a substantial computer to avoid upgrading in a few months. Invest in studio furnishings that will allow you to add matching components when you require additional furniture.

Scenarios C and D

These are more permanent situations typical of established professionals with strong client ties.

Good investments:
 ✳ adequate space, furnishings and equipment necessary for an efficient work station
 ✳ one additional phone line for your business phone (and possibly another for your fax and modem)

If you're working alone, you may want to structure your business as a sole proprietorship. However, also consider the advantages of structuring your business as a partnership or corporation, particularly if you're teaming up with another professional. In this case, contact a lawyer and accountant for more information.

CASE STUDY | Easing Into Entrepreneurship

Redman's Performa was originally purchased for her daughter while Redman was still employed. Now it serves as a word processing station and file server to Redman's printer.

S TEPHANIE REDMAN STARTED TO THINK ABOUT LEAVING A LUCRATIVE CAREER AS ACTING CREATIVE DIRECTOR AT A MAJOR PUBLISHING COMPANY WHEN TWELVE-HOUR workdays began to rob her of time she wanted to spend with her three-year-old daughter, Grace. Her managerial duties were also taking their toll in other areas of her life. "I was sitting through all of these meetings, and I wasn't doing a lot of creative work," says Redman.

But after seven years of working at the same firm, Redman had a hard time abandoning her executive salary and the other perks that come with working for a corporation: a 401(k) plan, health insurance and a corporate profit-sharing program. "I thought about it for eighteen months and had a lot of sleepless nights before I really started the wheels in motion," Redman relates.

Rather than make a clean break, Redman decided to gradually leave her full-time career and ease into a home-based design business. She started taking on freelance assignments—referrals from co-workers—about five months before she planned to leave. "I had been getting referrals for many years, but I just turned them down because I was too busy," says Redman. After getting permission to moonlight on company equipment, Redman did her freelance work

Photo Credit: Photo Art

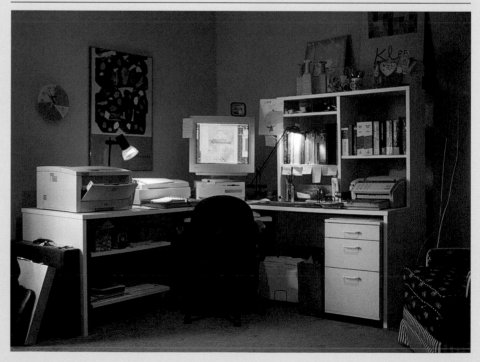

[Your Perfect Home-Based Studio]

STUDIO EQUIPMENT

Computers	Apple Macintosh Performa, Apple Power Mac 7300
Color Printer	Epson Stylus Color 3000
Black-and-White Printer	Xante AcceleWriter 8300
Scanner	UMAX Powerlook II flatbed scanner
Photocopier	Sharp combination fax/photocopy machine
Other	Sony Digital Mavica digital camera

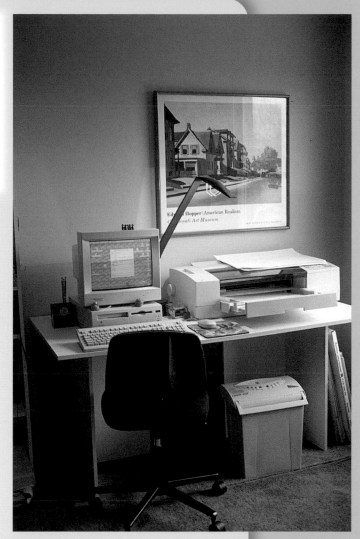

Redman works from two computer stations. Redman's Power Mac serves as her design workstation.

after hours at the office. "At the time I didn't have any computers at home, so I bought a couple of computer games and would bring Grace to work on Saturday morning," says Redman. "She sat at the computer next to me—while I worked— playing computer games."

Three months before she was ready to leave, Redman gave her notice, and traded her management position for part-time work for the remaining period of her employment. Working three days a week gave Redman time to set up her home studio and start contacting prospective clients. Her employer was pleased because Redman was available to help recruit and hire her replacement.

In October 1998, Redman officially began working out of her home full-time under the name Modern Design. Her studio consists of a converted bedroom in her fifteen-room home in Fort Wright, Kentucky, a suburb of Cincinnati. To be sure clients know she is committed to her business, Redman has established two business phone lines. With the business lines comes a business listing in the Cincinnati phone directory. "I wanted to assure them that they could count on me without a lot of personal issues inter-fering," says Redman. "I also made sure I had voice mail." Redman is also hooked

Redman works out of a converted bedroom in her northern Kentucky home. She makes the most of her space by using a combination fax/photocopier and a built-in storage closet for resource materials and records.

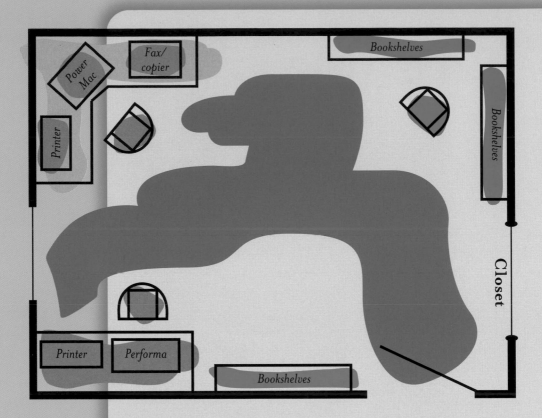

up for the Internet through her local phone company. Redman also acquired a post office box; its number appears on all of her invoices and business papers. "It acts as a shield in case home businesses are an issue for some people," she relates. Having a post office box also ensures that checks won't be stolen from her home mailbox.

Redman decided to equip her studio with computers she leases from a leasing service her former employer had used. Her three-year lease includes software installation and networking her equipment, as well as training—for an extra fee—if she needs it. Redman cautions that leasing equipment requires adequate insurance coverage. "It's like getting a car loan," she states. "You have to show proof of insurance before they'll lease you the equipment." To satisfy the necessary insurance requirements, Redman added a rider to her homeowner's policy that covers up to $32,000 in equipment.

Redman's familiarity with book design and publishing has helped her carve a niche in publication design. Her former employer, now a client, has given her many projects, including authoring a book on Web site design. ⌗

Redman's background in
book design has brought her
many freelance assignments
designing book covers and
jackets for publishing com-
panies, including her former
employer.

Redman tackles other
design projects unrelated to
publishing. Projects include a
brochure for a northern Ken-
tucky community center (far
left) and a set of invitations
to a local fund-raising event
(left and below).

START-UP CONSIDERATIONS

�ખ Whether you're starting a new business or setting up a contractual relationship with your current employer, it's important to consider some of the basic things that need to be done to establish a business and be sure you're in compliance with tax laws and local ordinances. This chapter will help you develop a plan to get these things done. ⟶

Choose a Business Structure

No matter how temporary or permanent your situation, you'll need to represent yourself as a business while you're working out of your home. Why? Because if you earn four hundred dollars or more per year working in your profession (beyond wages you earn as an employee), you must pay taxes on that income as a self-employed individual. This requires you to form a business with *you* as its employee.

For tax purposes, there are three types of business structures you can choose. You can establish your business as a sole proprietorship, a partnership or a corporation.

* **Sole Proprietorship.** As a sole proprietor, your business is you. You are responsible for any debts, legal obligations and liabilities, and you reap all of the profits from your business. No legal forms need to be drawn up when you form a sole proprietorship. You simply file a Schedule C "Profit or Loss from Business" at tax time along with your Form 1040. Your Social Security number is used as your business's federal identification number. (In some instances a sole proprietor must also have an Employer Identification Number, or EIN.) This is the simplest structure and the one most often chosen by creative professionals when they're starting their businesses.

* **Partnership.** A partnership involves two or more people in a situation where all profits, losses, legal obligations and other business liabilities are shared by the partners. Each partner's share is determined by a percentage of his interest in the business. The percentage is usually based on financial contribution, reputation and/or expertise. A lawyer (or lawyers—one representing each partner) must draw up a partnership agreement.

* **Corporation.** A corporation has nothing to do with the number of people involved in the business. One person can form a corporation and be its sole employee. The difference from sole proprietorships and partnerships is that a corporation is considered separate from the individual who owns it. Forming a corporation will safeguard you from personal liability, meaning your personal assets won't be affected if your corporation goes bankrupt.

When you incorporate, you become known as a C corporation, the first stage of incorporation. As a Subchapter C Corporation you'll have to pay corporate taxes on all profits; the profits distributed to yourself and other stockholders in your corporation will also be subject to personal income taxes.

To incorporate, contact the corporate division of your secretary of state's office to find out what your state's procedures are for incorporating. Pick a name for your corporation; you must clear it through the corporate division before you can incorporate. In addition to filing paperwork, you'll also need to acquire an EIN.

Once you've incorporated, you can elect to become a S corporation, in which you will be treated almost like a sole proprietor, avoiding double taxation. Your business profits are taxed once as personal income. It also offers many tax advantages.

Many creative professionals find the Subchapter S corporation offers an ideal combination of limited personal financial liability and single taxation.

Although corporations qualify for tax breaks, these may be offset by the expenses involved in forming a corporation. Filing the papers to form a corporation requires a minimal financial investment of two hundred to three hundred dollars if you do it yourself. If you choose to have a lawyer file, the cost jumps to around a thousand dollars. Consider as well that you'll probably want the services of an accountant, and you'll incur a charge for the initial consultation plus annual fees for the preparation and filing of corporate tax and/or personal returns.

You won't want to pay an attorney to draw up your incorporation papers if you plan to make less than ten thousand dollars a year or if your situation is temporary or indefinite. Many creative professionals with successful businesses advise starting as a sole proprietor and growing into the idea of incorporating. You can always re-evaluate your situation a few years down the road and decide to incorporate if your business growth warrants it.

Check In With the Local Authorities

In addition to Uncle Sam, most states also require you to pay taxes on the income from your business. Some cities and counties require self-employed individuals to pay income tax, as well. If you've been employed locally, your paycheck stub usually indicates which governments in addition to the federal government take a share of your income. However, the tax situation where you reside may be different from where you were employed if you worked in a neighboring county, city or state. Make sure you're aware of what your local tax obligations are and when you need to file. Your tax accountant should have this information.

You'll probably want to consider registering your business with your state's division of taxation if you plan to charge sales tax. Designers and illustrators should charge sales tax on most of the work they bill. If the project that you're working on is going to be sold to a third party, you don't need to charge sales tax; the sales tax will be collected when that item is sold.

An example would be designing and doing the production of a book, magazine or catalog that will be sold. On the other hand, if you do an illustration or ad design that appears within the book, magazine or catalog, you must charge sales tax on that. Sales of brochure designs, logos, letterheads, even packaging design and illustration are subject to sales tax.

The advantage of registering with the division of taxation is that you can qualify for discounts on materials used in the production of your work. The theory is that if you charge your client sales tax on a project, you shouldn't have to pay sales tax on the materials that go into that job—that's paying sales tax on the same item twice. Of course, you'll need to keep track of the sales tax you collect and send what you collect to your state division of taxation as often as your state requires (usually monthly). Your state division of taxation can provide you with more information on this. (You'll also find information on sales tax in chapter seven of this book.) ⟶

How Long Will It Take to Be Successful?

Hitting the big time with your home-based studio isn't likely to happen overnight. Unfortunately, those with home-based businesses can sometimes be perceived as freelancers working from their home in between jobs. This perception is especially true of those who find themselves suddenly out of work. If you're in this situation, clients wanting a long-term business relationship may be leery of dealing with you until you're more solidly established.

Even if you left your current job with the blessing of your boss and have won over your former employer as a client, it still may take awhile to get to the point where you're busy all of the time and making the kind of money you hope to make. Be patient. Experts say it usually takes at least three years to get to the point where your business is profitable. In many cases, it takes as long as five years.

Is Your Home Zoned for Business?

➤ Your home is probably not zoned for business, in which case you're working illegally from your home when you start your home-based studio. Zoning ordinances are created on the city or county level and vary widely from one area to the next. In some locales home businesses are permitted if you take out a business license. Other areas require you to apply for a home occupation permit before you can obtain a business license. Some cities and counties don't allow home businesses at all.

To make sure you comply with your local zoning ordinances, follow these steps:

* **First, determine if your city has any zoning ordinances.** You can usually get this information by calling your city's building inspector, planning department or zoning administrator. If the area in which you live is under county jurisdiction, your city officials should be able to direct you to contacts on the county level.

* **Find out how your property is zoned.** Cities or counties are divided up into four zoning classifications: residential, commercial, industrial and agricultural. Because farming is a "home business," most home businesses can operate in areas zoned for agricultural use. Areas zoned industrial allow business use, but usually prohibit residences. So if you're thinking of converting a warehouse loft into a home studio, an industrial classifica-

tion would prohibit your living there. A way around this is to contract with the building owner for you to provide security for the building. Industrial zoning usually permits night guards to sleep on the premises. Commercially zoned areas usually allow both residential and business use of property.

* **If your property is zoned residential, find out what your obligations are to operate a home business.** You may be required to purchase a permit. Find out, as well, if there are any restrictions. In some areas, residential zoning prohibits any kind of business activity. In most cases, a residential classification just limits the scope of business being done in the area. Established professionals—such as physicians, dentists and lawyers, as well as creative professionals—are usually allowed to conduct business from their home.

Many creative professionals with home studios claim that their business has very little, if any, impact on their neighbors. Problems can arise, however, if your home is not zoned for business: neighbors could turn you in because a courier kicks their dog—or worse, he injures their kid with his truck; installing a business phone line could prompt a zoning official to contact you. If you're operating in an area not zoned for business, contact your local chamber of commerce or business owners in the area to find out how you can avoid these types of problems.

Establish an Identity

To avoid confusing your personal assets and liabilities with those of your business, you'll need to establish a name for your business. If your name is Jane Doe, the name of your business can be as simple as Jane Doe Graphics. This approach makes sense if you're working out of your home until you get a salaried position and want prospective employers you're working for to remember your name. It's also a good idea if your name has high recognition value—illustrators are often in this position. However, if you're setting up a design studio that's going to be a permanent endeavor, you may want to choose a name that's going to make a strong impression or play up one of your firm's unique features. Just be sure it's one you can live with. You don't want to confuse your clients by changing your business's name down the road.

It's important to use your business name when you open a separate bank account for your business, establish credit and, of course, file a tax return for your business income. Your company name will also serve as the basis for your *identity*—a means of identifying your firm with a logo, letterhead, business card, other business papers and materials, and possibly a Web site.

Business cards, letterhead and business-sized envelopes bearing your company name and/or logo are essential to doing business. Some other printed components that you may want to consider using are:

* **Invoice forms.** You'll need to clearly mark your invoices so that they're immediately perceived as bills for services rendered and not confused with ordinary correspondence. To save money, you can use your business letterhead for invoices and print the word invoice at the top when you print the actual invoice off your studio printer. Be sure *invoice* is displayed prominently and looks as though it's part of your letterhead design.

* **Fax cover sheets.** The sheet that precedes faxed materials should display your company name and/or logo, phone and fax number. It needn't be in color—it's obviously going to be received by your client as a black-and-white image—but it should be designed so that it's compatible with your letterhead. Fax cover sheets are often designed in a half-page format because the information they contain

is minimal—usually the name of the recipient, the date the fax was sent and the number of pages faxed. Because time spent faxing is charged as phone time, half sheets can help you save money on long-distance calls.

* **Shipping labels for large envelopes and packages.** These clearly let recipients know that the package came from your firm. They also bear your return address, saving you the time of writing it on the envelope or package. If you have minimal need for these, you can use blank laser-compatible peel-and-stick labels to print out labels on your laser printer, saving you the expense of having them commercially printed.

* **Labels for computer diskettes.** You want your stuff returned, so it makes sense to identify your diskettes with custom labels. These also offer an additional opportunity to put your name in front of your clients. You can have these offset printed commercially on self-adhesive label stock or print them on your own laser printer. Include your company name, as well as *return to* (if you wish), then affix them to your diskettes.

* **Stickers bearing your logo and/or company name.** These can go on anything and instantly customize your business materials. Some of the most effective applications are stickers bearing a logo without a company name. Slap them on presentation folders, CD-ROM cases, flap sheets covering an illustration, express shipping packages or other parcels. Be creative! Like shipping labels and diskette labels, these can be offset printed in large quantities or printed on your laser printer for smaller quantities.

Develop a Business Plan

Writing a business plan is essential when applying for a bank loan, but there are other reasons for developing a business plan—even if you don't need financial help. Writing a business plan forces you to clarify your business goals, intentions and strategies. Your business plan will also help strengthen your sense of commitment by serving as a written declaration.

Your business plan should communicate your:

* **Mission Statement.** Your business plan should start with a mission statement that says more than "graphic design" or "illustration." State in a sentence or two a summary of your business goals, your intended clientele, your intended specialty plus your business function. Examples of mission statements are:

"To supply graphic design to high-tech, animation and other technology-oriented industries."

"To illustrate children's books."

* **Rationale.** Develop a statement of purpose. List the reasons you are going into business and the goals you expect to fulfill. Explain how you will offer something unique and marketable to your clients.

* **Business Goals.** Include a list or statement of your business goals. Go into detail about the types of clients you'll serve. Be specific about what kinds of projects you'll take on and how long they will take you to do, as well as when you expect to be paid. State how much you want your business to earn and what you'll earn as a salary. Establish a time frame for fulfilling your business goals.

* **Marketing Strategy.** Give details about how you plan to achieve each of your business goals. State who your intended clients will be, how you'll acquire the business you want and what your promotional strategies will be. Identify your competition and discuss how you will compete effectively.

* **Business Structure.** State what your business structure will be: sole proprietorship, partnership or corporation. If others will be involved in your business as partners or staff, state who they are and what they will do. If you'll work alone, state what your responsibilities will be.

* **Location.** State that you'll work out of your home, and explain why this is an optimal location for your business. Describe your home studio's environment, and be specific about it will be equipped.

* **Five-Year Plan.** Work out income projections based on what you plan to charge for your projects. Detail what your expenses will be, and develop a profit and loss statement for each of your first five years of business.

Get Financial and Legal Advice

Anyone who establishes a business needs a tax accountant and a lawyer. Your lawyer will help you file papers of incorporation (if you incorporate), look over contracts, go after clients that don't pay their bills, and deal with any other type of litigation. An accountant will give you tax advice, help you file the necessary tax returns and, if you need it, help you set up a bookkeeping system. You may also want a financial advisor—someone who can give you advice on long-term financial planning, such as how to best invest your business income and plan for retirement.

The best way to locate such professionals who have experience working with creative professionals is to ask colleagues for referrals. You don't necessarily want to hire your cousin's brother-in-law or use this as an opportunity to grant a favor to a friend or relative. Hire the fairest and most competent individuals you can find.

If you already have an accountant whom you're happy with, ask her to recommend a lawyer or, conversely, ask your lawyer to recommend an accountant. If you're not able to get referrals from others practicing in your field or others whose opinion you trust, search the yellow pages; when you call, ask specifically if anyone in that office has experience with small business or creative professionals. Here is some specific advice on finding professionals who are competent and trustworthy.

Accountants

* You might want to work with a tax accountant who is not a CPA (Certified Public Accountant), particularly if you're just starting out or uncertain about how long you'll be in business. Tax accountants charge less, and tax advice is more than likely all the expertise you'll need at this point. CPAs can do audits and may be better prepared to advise you on long-term planning, particularly if you end up forming a corporation. But I've found that my tax accountant and financial planner together have given me all of the financial advice I've ever needed.

* Arrange an interview, and be prepared to provide information as well as ask questions. Start the interview by letting the accountant know what type of business structure you're choosing (sole proprietorship, partnership or corporation). If you're undecided, ask for advice on which structure you should choose. Ask what she would charge to file your annual taxes. Ask what she will need from you in order to file them. Ask what she would charge for other advice or to file quarterly tax returns. Find out if she will provide you with a work sheet that will help you organize your financial records in advance of filing tax returns. If you're considering purchasing a major piece of equipment, ask her how you can write this off. A good tax accountant should have a plan for amortizing large purchases.

* Evaluate how this individual responds to your questions. If she spends much of your time talking about how you can evade the IRS, look elsewhere. A good

accountant will understand how you can make tax laws work to your advantage, but would never encourage illegal activity that could put you in jeopardy if you're ever audited. A good accountant should explain things in a way that makes it easy for you to understand. If she intimidates you with a lot of financial jargon or divulges any information to you about another client, forget her. Although you're asking for fee information, don't let this be the sole criterion on which you base your judgment. It's more important to find someone you can understand, feel comfortable talking with and trust.

Lawyers

* Try to get more than one referral so that you have some point of comparison. Then, call to arrange interviews with the lawyers you're considering. Ask if you'll be charged for the interview. A lawyer who charges you for the opportunity to promote his services isn't worth considering. He's obviously more interested in your money than your business.

* During the interview, find out how the lawyer charges—by the hour, per project or on a retainer basis (a base fee against which legal fees and expenses are deducted). If a lawyer operates on a retainer basis, find out if the unused portion of your retainer will be returned to you if and when you terminate service. If he's not up-front about what he charges, forget him. Whatever the fee arrangement is, find out if he has a written agreement that details all fees and services.

* Hire a lawyer you feel comfortable talking with and who has the ability to understand your situation and make recommendations on how to best handle any circumstance that requires legal expertise. Find out if you'll be working with this individual exclusively or if some of your needs will be handled by an associate. If you're seeking specific information on forming a corporation or partnership or on some other matter, ask him what he would advise. Ask what would be involved if this individual wrote up a partnership contract or filed papers of incorporation.

* Evaluate how this individual responds to all of your questions. You want someone who can explain things so that you understand them. You also want someone who is adept at settling disagreements out of court. If he uses a lot of legal mumbo jumbo or gives you the impression that he's interested in going to court, forget him.

* After hiring a lawyer, keep track of the correspondence you receive, as well as time you spend on the phone or in personal meetings with that individual or any of his associates. If there's ever a question about how you've been charged, you'll have documentation on hand to back up your contention.

CASE STUDY | Husband and Wife Become a Corporation

> *"Living and working in a pastoral environment gives us an edge on urban studios."*

GREG WOLFE

MAGINE A WORK ENVIRONMENT WHERE YOU CAN STEP OUTSIDE, INHALE THE SCENT OF FRESHLY MOWN HAY AND WATCH HORSES PLAYFULLY NUDGING EACH OTHER IN a nearby pasture. This bucolic vision isn't a pipe dream—it's where Gregory Wolfe Associates Inc. (WA) has set up its home-based studio.

Situated close to Blanchester, Ohio—a small town halfway between Cincinnati and Columbus—WA is a joint venture that combines the talents of husband-and-wife team Greg and Beth Wolfe. Established by Beth Wolfe in 1985, WA grew out of her desire to work as an independent designer from their rural home. "I went right into having my own business after leaving school," explains Beth, who was fortunate to land a contract with Cincinnati Bell shortly after graduating.

As her business grew, Beth found herself increasingly turning to Greg for assistance. "Up until the summer of 1999, my role was support and consulting," says Greg. But at that point, the workload became so intensive and the business prospects so attractive that Greg decided to resign from his teaching position at the Art Academy of Cincinnati to join his wife as a full-time employee and partner in the business.

While they share the firm's design work, the couple's roles in other areas of the business are well defined. Beth serves as primary client contact, while Greg provides photography and technical support. They also split administrative tasks. "I do the invoicing, and he pays the bills," relates Beth. They feel clients benefit from their combined expertise when it comes to concept development. "We'll both develop ideas, look at them, throw some out, keep others and provide the client with a mix of concepts," explains Greg.

One of WA's chief selling points is that it can do both photography and design, enabling the firm to offer quicker

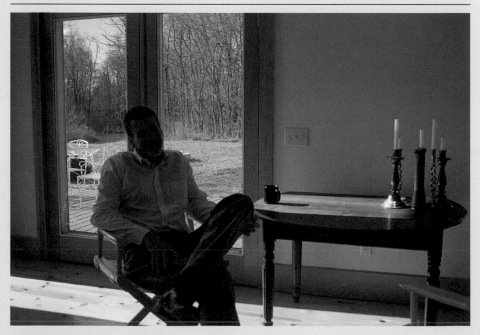

Greg Wolfe relaxing at home.

26

[Your Perfect Home-Based Studio]

turnaround time than design studios that need to hire an outside photographer. Their average turnaround time improved even more with their recent purchase of a LightPhase digital camera.

The building that houses the couple's combined studio and living quarters was built in 1996 and was designed to integrate WA's business needs with the couple's living environment. Its twelve-foot ceilings accommodate the scaffolding necessary to light studio setups. Slim floor-to-ceiling windows provide an abundance of light without limiting wall space for equipment, shelving and other means of storage.

The Wolfes' five-room house includes two rooms dedicated solely to the business—one for design and another for photography and photo editing. A third room with an adjoining kitchenette and pantry serves as a multipurpose area—a conference room, a dressing room and photo styling area for models, or a place for meals or entertaining when work is done. The one area that's used exclusively for living quarters is the couple's bedroom and master bath. During a recent photo shoot, a photo stylist referred to WA as the "little big studio" because she had

never seen a small studio produce such a variety of sets and shots from such a limited space. Greg and Beth's future plans include building new living quarters, an addition that will turn the present building space into solely business space. The current arrangement allows WA to write off about 50 percent of their home expenses as business related.

Until 1999, Beth ran the firm as a sole proprietorship. But when Greg joined as an employee, it became more advantageous to structure the business as a Subchapter S corporation. The couple chose this business structure for a number of reasons. "A corporation offers more tax incentives as you add employees and grow," says Greg. The firm's corporate status also made it easier for them to get group health and dental insurance. "It's not as easy to do that if you're a sole proprietor and you're working from your home," Greg explains. "They're more likely to look at it as a temporary situation." Greg also points out that clients may be more comfortable working with a firm that's categorized as a corporation. It saves them the trouble of filing a 1099 Miscellaneous Income form annually for the fees they pay.

The Wolfe's work space includes a room devoted exclusively to photo shoots and photo editing.

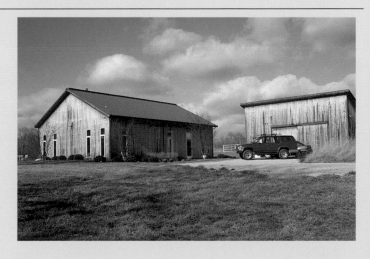

The Wolfes built this five-room farmhouse to accommodate a flexible work and living arrangement. The barn next door houses photo equipment as well as farm equipment.

The firm's rural location has presented a few challenges. The Wolfes say power outages are more frequent there than in metropolitan areas. They were able to solve that problem by installing a battery back-up system to ensure that computers and other equipment won't shut down when the power goes off.

But the studio's pastoral surroundings have also offered many unexpected advantages, including plenty of photo opportunities. With 154 acres at their disposal, the Wolfes can easily create a variety of settings. They've even dumped a truckload of sand onto their lot to shoot a model in a beach scene. Looking out on the lake, located adjacent to the studio, Greg comments, "Living and working in a pastoral environment gives us an edge on the urban studios that are caught up in the mainstream solutions. We have the opportunity to bring a fresh look to our clients' projects."

Greg and Beth Wolfe's studio space comprises one-half of their home. Two rooms are devoted exclusively to the business, and one room serves as a combination conference room and dining area.

STUDIO EQUIPMENT

Computers	Apple Power Mac G3 (two laptops), PC station
Color Printer	Epson Stylus Color 3000
Black-and-White Printer	Apple Laserwriter II, Hewlett-Packard 1600CM black-and-white printer
Scanner	HP 3CT flatbed and slide scanner
Other	LightPhase Hasselblad digital camera

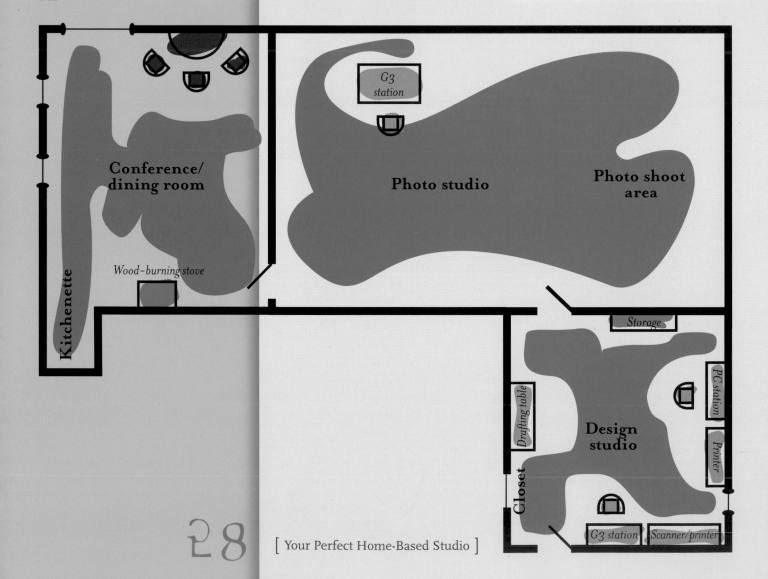

Conference/ dining room

Photo studio

Photo shoot area

G3 station

Wood–burning stove

Kitchenette

Storage

Drafting table

Closet

Design studio

PC station

Printer

G3 station

Scanner/printer

WA also does projects for several industrial firms in the Cincinnati area, including Tekmar-Dohrmann, a manufacturer of medical and pharmaceutical equipment (right and far right).

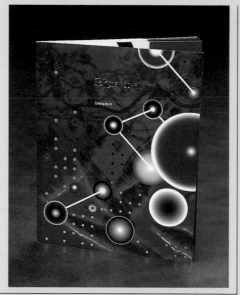

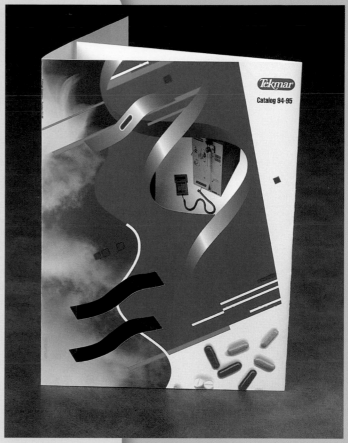

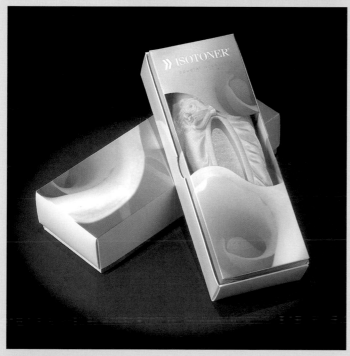

One of WA's largest clients is totesIsotoner Corporation, based in Cincinnati, Ohio. The firm's work includes packaging design and photography for totesIsotoner products.

The firm's photographic work often combines traditional photography with digital special effects.

WHERE WILL YOU FIND BUSINESS?

�֍ Determine your niche by considering which types of businesses you'd be happiest working with and what kinds of projects best suit you. This chapter groups potential clients into six business categories: 1: agencies and design studios; 2: publishers; 3: small businesses; 4: large companies and corporations; 5: nonprofits and institutions; and 6: printers. Each business category offers a different kind of working situation. Once you determine which type of client you're best suited to working with, you can focus your promotional activity on the business group which you're most likely to engage with. —————————→

Agencies and Design Studios

Design studios and ad agencies often do the same type of print work and frequently collaborate on jobs. Illustrators and calligraphers are usually hired by agencies and studios to produce work that can't be done in-house.

Designers doing freelance work for agencies and studios often find themselves taking on work when the firm needs to supplement their labor pool. Projects generally fall into one of two categories of work:

1. Production work based on a design standard already established by the studio or agency. This type of project typically elaborates on an established design theme; for instance, a letterhead design needs to be developed into other identity materials.

2. A design project where the designer is hired to come up with a concept that's different from the "looks" submitted by staff designers. These projects include logo designs, packaging or cover concepts, or any other situation where the designer starts from scratch. Studios and agencies often hire freelancers for this type of work so they can offer a client additional options. Although there's no guarantee that a freelancer's design will ultimately be chosen and printed, this type of work pays better than production work because it demands more design expertise.

One of the best ways to engage agencies and studios is to network. Attend meetings for local ad clubs, the American Institute of Graphic Artists (AIGA) and Art Directors Club. Talk about your experience and make sure people know that you've established your own business. Bring plenty of business cards to pass around.

Newcomers to the field or those who have moved into a new location often benefit from sending out a self-promotion piece introducing themselves to the creative community. A self-promotion piece gives studio owners an idea of the design capabilities you offer. If it's clever and well designed, it's a good way to get your foot in the door. The yellow pages are an obvious source for a mailing list of studios and agencies in your area. Call to find out whom you should direct your self-promotion piece to (generally the firm's principal or creative director). After you've sent your promotion, follow up with a phone call to see if you can schedule a portfolio showing.

If you enjoy working with other creative professionals and flexing your creative muscle, you'll probably be happiest working with clients from this group.

How to Reach Book and Magazine Publishers

This book offers a list of hundreds of magazine and book publishers that buy illustrations. In addition to contact information, each listing tells how to submit work, how many illustrations are purchased in a year and other useful information. The book also includes listings for greeting card companies, art galleries and multimedia and animation markets. Contact F&W Publications, 1507 Dana Avenue, Cincinnati, Ohio 45207, (513) 531-2222 (Web site: www.howdesign.com).

Society of Children's Book Writers and Illustrators (SCBWI)
This group sponsors conferences where illustrators can show their portfolios to potential clients. Contact them at SCBWI, 8271 Beverly Blvd., Los Angeles, California 90048, (323) 782-1010 (Web site: www.scbwi.org).

Most book and magazine publishers are constantly looking for illustrators. The ability to send files over the Internet and via overnight couriers means an illustrator working in Paducah, Kentucky, is just as likely to land an assignment in New York City as one based in Brooklyn, New York.

Magazine art directors often respond to regular mailings from illustrators. Sending out a monthly or bimonthly post-card with an illustration on it serves as a constant reminder of who you are and the kind of work you produce. If your illustration style isn't suited to any of the articles featured in the issue on hand, chances are usually good that one of the next post-cards you send will strike a chord with a magazine art director. Many art directors also file these samples according to style, then contact an illustrator whose illustration style fits a particular feature.

Book publishers also offer a wealth of opportunity for illustrators, ranging from children's books to book covers. Some illustrators have been able to land assign-ments by sending out a package of printed samples to a list of prospective publishers. Because so many are based in New York City, successful illustrators in this market also advise illustrators looking for work to make a trip to New York. Call ahead and make arrangements for port-folio showings with the publishers that you think would be most responsive to your work.

Graphic designers are often hired by publishers for cover designs, book and magazine design or production work. Book and magazine design and produc-tion assignments generally go to de-signers with experience in the field. How-ever, publishers looking for fresh ideas often hire designers for cover concepts and masthead designs. Publishers also have a need for print promotion and often hire graphic designers to produce ads and direct mail pieces. The best way to find local publishers is to search your yellow pages or network through your local AIGA chapter or Art Directors Club.

Small Businesses

Small businesses are all over your community. They include restaurants, dentists, insurance brokers, health clubs—you name it. These types of businesses usually look for reasonably priced design work on an infrequent basis. Start-ups usually need logo, business card and letterhead designs. Restaurants obviously need menus. Small businesses also seek out design services for direct mail pieces, flyers and brochures.

Because their design needs are occasional, small businesses don't usually go to design firms or ad agencies; they often turn to printers for design services which sometimes fall short of what a professionally trained graphic designer can produce. Often your best leads come from simply observing the quality of a business's current printed materials. If they need improvement, offer your services to the proprietor.

It's not important to dazzle small-business owners with an extensive portfolio; your business card and samples of projects or work that you've done for similar clients will suffice. But be prepared to sell the effectiveness of good design to small business owners. Pitch the importance of a good image and how a professionally designed piece can help improve sales or bring in new business. Clients in this market segment are more interested in how your work will bring about positive results than they are in how your cutting-edge work was recently featured in a national design annual. They want to be convinced that your design can communicate effectively to their intended audience.

A word of advice: small businesses can sometimes be unpredictable when it comes to paying bills, particularly if they use your services on a one-time basis. Check out prospective clients with your local Better Business Bureau or other local sources to be sure that they have a reputation for paying their bills. Be especially wary of new businesses.

One way to avoid the problem of collecting fees for your services is to work out trades with businesses you frequently use, getting paid in products or services for your design expertise. Does your hairdresser need a new sign? Did your financial advisor recently jot down his phone number on a piece of paper because he ran out of business cards? Any business that's moving to a new location will need new business materials and possibly signage. When you notice a need for printed materials or a new design, offer your services in exchange for theirs. Most business owners will jump at the chance to bypass paying for the design services they need if they can work out a trade.

Large Companies and Corporations

In addition to staffing an in-house design department, large companies and corporations are likely to hire design firms and advertising agencies to supplement their design needs. The in-house design department typically handles day-to-day design responsibilities and works with outside agencies and studios on special projects.

Design projects run the gamut, depending on the company. Manufacturers, retailers and service providers need brand and packaging development, promotional brochures, catalogs and other print collateral, ads, annual reports, newsletters, identity development and environmental graphics as well as the usual business materials.

Although high-profile advertising agencies and design firms often service large companies and corporations, there's no reason why somebody operating from home can't compete for these accounts. Be able to demonstrate with examples of work you've done for other clients that you have the experience and reputation for dependability; many companies are willing to go with somebody new if they want a fresh approach and like what they see in the portfolio.

It's important to do some research on the companies you're interested in working for to determine where your style of design might fit and the types of design projects they need that you're best suited to handle. When approaching a large company, it often helps to have a specialty—something you've done for many clients with a large degree of success. If you can produce a great-looking catalog under impossible deadline situations, take your portfolio of catalog samples to manufacturers that issue catalogs. In addition to knowing the company's primary business and something about their promotional and print needs, have some idea of what type of image they promote to be sure your design style is in step with theirs.

Be sure you direct your efforts to the right person. When cold calling, find out whether you need to arrange an interview with the corporate communications director, creative director, marketing communications manager or another executive.

Nonprofits and Institutions

Nonprofit organizations include charities, arts organizations, theater companies, performing arts groups, museums and zoos. Institutions include schools, hospitals, professional organizations and foundations. Institutions can be run for profit or as nonprofit organizations.

Because they're on a limited budget, nonprofit organizations and institutions offer an excellent opportunity for students and other newcomers to the field to get a start on their career. Many award-winning posters have been done by talented young designers and illustrators as pro bono jobs in exchange for printed credit. Arts organizations in particular often seek cutting-edge design and are willing to grant a lot of creative freedom to a talented newcomer. These types of projects bring a lot of public recognition to the designer and/or illustrator involved and have been instrumental in launching the careers of many successful creative professionals.

In addition to posters, nonprofits and institutions have other fund raising and publicity needs. These include newsletters and direct mail, logos and identity materials, T-shirts and other merchandise bearing their identity.

Many creative professionals feel good about contributing their expertise to nonprofits and institutions because they believe in the organizations' causes. In fact, it's not unusual for home-based designers to produce their own church's newsletter or bulletin or provide similar design services to a school that their children attend.

If you tend to be idealistic and you like working with others with high ideals, you may prefer working with nonprofit organizations and institutions simply because you'll be in the company of individuals much like yourself.

Printers

Printers will often offer design and illustration services to their clients, then farm out these projects to creative professionals they know they can rely on. This is a good opportunity for newcomers to the field to learn about prepress production and build a portfolio. However, the creative potential in these types of jobs is often limited.

Because they often offer little, if any, opportunity for interaction with the client, printers' projects are usually simple, straightforward and more production oriented than design oriented. Because the printer bills the client (and usually charges a fairly low rate), you probably won't be able to charge the printer very much for your time. However, if this is a comfortable and mutually beneficial arrangement, the work—and income—can be fairly steady.

Is Your Niche in New Media?

Everybody seems to want a Web site. If you have the expertise to capitalize on this, you'll probably have very little trouble getting business. Nevertheless, to get started, you'll need to get your name out to business owners and others wanting a Web site. Here are some tips on how to promote yourself and get work in this area:

Build your own Web site. Those who have made it in this area say that your Web site is your best promotional tool. You don't necessarily have to know about HTML scripting or coding. Visual editors such as Adobe GoLive, Macromedia Dreamweaver and Microsoft FrontPage make it fairly easy to design Web pages. As you get increasingly involved in designing Web sites, add these clients' names and links to their sites to your Web site. Pretty soon, business will come to you via word of mouth.

Network. Networking becomes especially important when you're trying to cultivate Web site business.

Attend as many business functions as you can and distribute your business cards showing your Web site address.

Do pro bono work. Developing a Web site for your local civic group, church, professional organization or school is a great way to expose others to your capabilities.

Partner with technicians. Web sites are often collaborations between designers and Web technicians. Many print designers getting started in Web design can find technicians to partner with by networking through user groups.

Check online job boards. When you develop the experience and confidence necessary for working online with clients outside your local area, search online job boards, such as www.monsterboard.com and www.adobe.com/jobconnection, which offer many listings for Web designers.

Assemble Your Portfolio

First, purchase a binder, box or briefcase that is produced specifically to serve as an artist's or designer's portfolio. Art supply stores sell briefcases and binders. If you're an illustrator with mounted transparencies of your work or a designer with magazines or other publications to show, check photo supply stores for clamshell boxes. Light boxes can often be purchased to fit within the box. If you want something really special, check the ads in the back of design magazines for companies that sell custom portfolios. They can be covered in a variety of materials and imprinted with your firm's name.

Determine what your portfolio will include. Most people prefer looking at printed samples of your work. If you have a lot of experience and many printed samples to show, customize your portfolio according to the job. A client interested in hiring you for an identity redesign is obviously going to want to see identity and logo designs you've produced for other clients. Mounted samples in a box or binder sleeves can easily be interchanged to meet your presentation needs.

Limit your selections to ten to fifteen pieces. If you're a newcomer, pick your best work. If you have only eight great samples, don't dilute the quality of your portfolio by throwing in two mediocre pieces just to have ten samples. Make absolutely sure to include only smudge- and tatter-free pieces. The quality of the samples you display is a reflection of your pride in your work. Never include messy, dog-eared samples in your portfolio.

People tend to remember what they see first and last, so place your best and/or most colorful pieces in the front and back of the portfolio. Be sure your work is displayed in a way that makes it easy to appreciate all aspects of each project. Packaging design and illustration should be presented with a photograph of the finished package as well as a separate print of the graphic or illustration used on the packaging. An identity system should include the letterhead, business card and all other business papers you've designed. If you use a binder, arrange all components of a project on a single page or spread. Display three-panel brochures by showing the cover and, if you have more than one copy, the unfolded interior. Brochures and publications can also be placed in a sleeve with the cover showing, then pulled out during the presentation so that the interior can be viewed.

Present Your Portfolio

Put Your Portfolio Online

Don't forget that a great way to promote your work is by posting your portfolio on the Web. If you categorize your work (and most creative professionals' Web sites do), viewers may want to see as many as eight to ten examples in a given category and ignore other categories that don't apply to their project needs.

Illustrators wanting to put their portfolio online don't have to post their own site. Theispot-Showcase (www.theispot.com) offers this service to illustrators for an annual fee.

The best place to show your portfolio is at the corner of a conference table or other table. This situation allows you and your client to easily view your work together, with you "sharing" rather than "showing." Sitting on the opposite side of a desk makes you look at your work upside down—a somewhat awkward situation.

You should be at the same eye level as your client and in a relaxed position. Standing together tends to create a hurried situation. Standing over a seated individual while presenting your portfolio creates the impression that you're dominating the situation. Try to create an environment that's conducive to establishing rapport and generating an equal exchange of information.

Limit any talk about yourself and try to discover the interests, needs and business goals of your client. If your portfolio showing has been arranged because the client is interested in having you do a specific project, you already have some idea of what their communication and project objectives are. Try to find out more and, at the same time, put your client at ease. Look around the office for something that will spark a casual conversation. In addition to establishing a friendly, relaxed tone, this immediately puts the focus on the client.

As you find out more about your client's business and communication needs, you can focus your presentation to show your client how your design expertise can help meet those needs. Focus on the projects that have the most relevance to the client's business or marketing situation. Talk about how the samples you're showing solved a specific marketing or communication problem. Be prepared to talk about money—the production costs of a particular project, how your design solution saved a client money, and deadlines. Illustration buyers are particularly intent on finding out how quickly you can turn a project around.

If you successfully establish rapport with your client, you should have a strong sense of how long the meeting should last. Although you may talk at great length about the client's business or the project at hand, your portfolio presentation should usually be limited to five or ten minutes. Be aware of your client's body language. If he starts to look at his watch or seems distracted, take this as a cue to wind up your presentation.

Before you leave, give your client something to remember you by. What you give him should suit your situation. If you're interested in doing a specific project, your business card or a label attached to an envelope of samples of similar projects will give your client something to refer to after you've left. If he hasn't already received it, you can give him a self-promotion piece.

The All-Important Self-Promotion Piece

After an interview and portfolio showing, many design firms, freelance designers and illustrators give their clients a bound promotional brochure or other promotional package featuring samples of their work, a summary of their experience and a list of clients and awards. This allows clients to revisit the material after the portfolio is gone.

Such a self-promotion piece can also help you get your foot in the door by giving your clients an idea of your experience and your capabilities. When you want to meet with a client about a specific job or just schedule a portfolio meeting, send your self-promotion piece with a cover letter expressing your interest in a meeting. If they like what they see, they're more likely to respond positively when you call to schedule a meeting.

Think of your self-promotion piece as a mini-portfolio. It should show samples of your best work and serve as an example of your design and conceptual capabilities. If you're going to mail it, it needs to work effectively as a direct mail piece. It also needs to work as a well-designed brochure (if it's bound) or packaging concept (if you decide to bundle samples in a box). Put as much effort and imagination into designing your self-promotion piece as you would put into a client project.

Consider how your samples would best be presented and how much flexibility you need. If you're an illustrator, you might want to do postcards, each with an illustration printed on one side. That way, you can mail them separately on a monthly basis or bundle them together in a box or folder as a mini-portfolio. If you're a designer, you may want to consider doing something similar to have the flexibility of including samples that are targeted to a specific type of client or project. If you want to include copy to explain the objectives behind each project presented, a brochure might be your best option. You have many ways to bind the brochures yourself for the flexibility of customizing them.

For more ideas on self-promotion pieces, consult trade magazines. *HOW* magazine publishes an annual issue dedicated exclusively to self-promotion. Other trade magazines that publish design annuals also feature winners in their competitions' self-promotion category.

It's not essential that you have a self-promotion piece; however, newcomers to the field especially can find one to be helpful. An exceptionally clever and well-designed self-promotion piece can often open doors when a call or letter won't.

CASE STUDY | **Shared Disciplines and Dreams**

THOMPSON STUDIO

"It's a business. We're not just artists waking up and doing what we want."

GEORGE THOMPSON

George and Emily Thompson.

ILLUSTRATORS GEORGE AND EMILY THOMPSON OF THOMPSON STUDIO WERE IN AN EXCELLENT POSITION TO KNOW WHAT ART DIRECTORS WANTED FROM ILLUSTRATORS when the two decided to go into business: Each of them worked as an art director at Bloomingdale's before deciding to start a home-based business. "We know what it's like being on the other side of the fence," says George, who left Bloomingdale's in 1989 to work as a freelance illustrator.

After watching George's freelance business grow, Emily—who had worked for ten years as an art director in the Bloomingdale's advertising department—started moonlighting as an illustrator to test the waters. After a short while, as more and more assignments came her way, Emily left Bloomingdale's in 1994 and decided to form her own illustration business as well. "I was juggling two full-time jobs," she explains. "When I started

doing well with the illustration, I thought, 'That's it.'"

George and Emily have been working out of shared home studio space since they started freelancing. "When we first started out, we were in a studio apartment. We had one table, and we shared it," says Emily. The couple moved out of their Astoria, Queens-based studio apartment in 1993 and into a two-bedroom apartment off of Times Square. "We had our own tables and lamps," Emily relates. "We thought it was a luxury." The couple initially relegated one bedroom to their business, but they found as their business grew that their reference libraries, computers, scanners and photocopier spilled over into the living room. Before long, their business had taken over two rooms—one-third of their apartment. And because they were renting, they had to use a single phone line for all of their business and personal calls as well as their fax and modem.

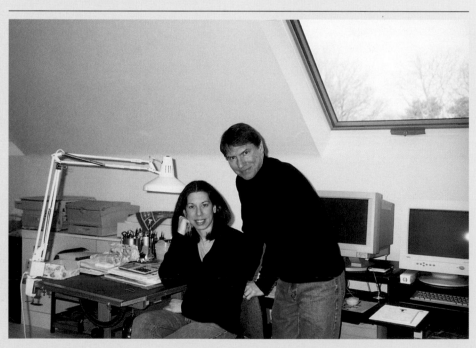

The Thompsons marked the year 2000 with the purchase of a house in Doylestown, Pennsylvania. The house afforded the opportunity to renovate the attic into a studio loft. The house is only a ninety-minute commute from Manhattan, but George and Emily work for clients all over the country. They've found that some of their pen-and-ink and watercolor work can be scanned and sent to clients via the Internet.

The Thompsons attribute much of their success to an effective (and persistent) direct mail campaign. "We compiled a list. We went to newsstands to look up the names of art directors in magazines," says Emily. The couple also visited the library and added book and newspaper publishers to their list. From there, they had postcards printed. "We went to a quick print service," says George. "The postcards were black-and-white and really cheap, but we got a lot of work from that."

After a few years of doing six postcard mailings per year, George and Emily were getting plenty of assignments from publications such as *The New York Times* and *Barron's*. Feeling they had satisfied their black-and-white self-promotion needs, they started to invest in printing four-color postcards. Since the mailings began in 1994, they have grown from one hundred to two thousand cards per mailing. "After awhile, people end up with a pile of our cards," says Emily. "Art directors say, 'I have a huge file of your stuff. I've been wanting to call you for a long time.'"

In spite of sharing studio space, the Thompsons work independently. They have their own clientele and create their own postcard illustrations. Only recently did they decide to combine their postcard mailings by placing both of their cards in

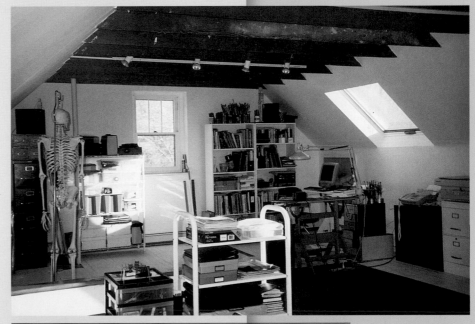

The Thompsons recently remodeled their home's attic to serve as a studio. Improvements included installing skylights, refinishing the floor and adding drywall, new wiring and track lighting.

STUDIO EQUIPMENT

Computers	Apple Power Mac G3, Apple Macintosh Quadra 650
Color Printer	Epson Stylus Color 850
Black-and-White Printer	Apple LaserWriter Select 360
Scanner	Agfa Arcus 2 flatbed scanner
Photocopier	Canon PC7 tabletop

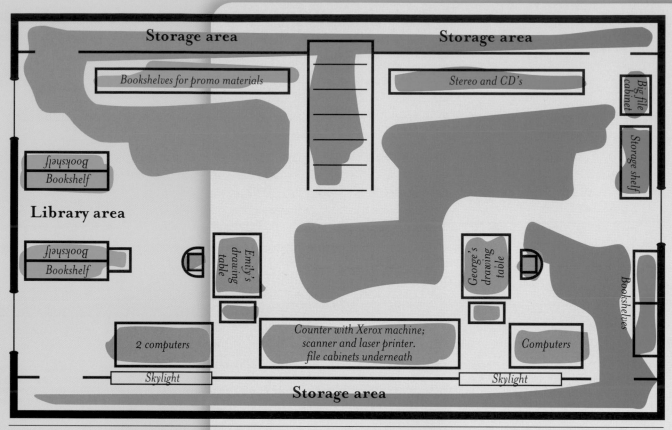

Storage area

Storage area

Bookshelves for promo materials

Stereo and CD's

Big file cabinet

Storage shelf

Bookshelf
Bookshelf

Library area

Bookshelf
Bookshelf

Emily's drawing table

George's drawing table

Bookshelves

2 computers

Counter with Xerox machine; scanner and laser printer. file cabinets underneath

Computers

Skylight

Skylight

Storage area

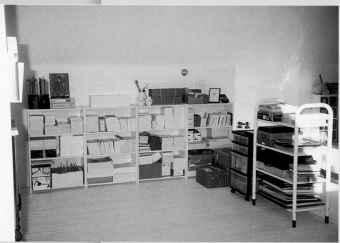

Thompson Studio's converted attic space offers optimum lighting and plenty of room for two people to work.

the same envelope with "Thompson Studio" printed on the outside. "We save postage that way," says Emily.

As a married couple, George and Emily file a joint personal tax return, but each files a separate Schedule C as a sole proprietor. "Checks come to Emily or to me," George explains. "They don't come to Thompson Studio."

The Thompsons are quick to point out that having a successful home-based business requires a lot of discipline. They stick to a strict routine. "The comforts of your home can distract you," explains Emily. "We start at 9 o'clock, and we're here all day at our desks working. Some of our freelance friends will wander around during the day or sleep until noon. You can't do that." ⌗

Emily's work has also extended into a greeting card design and a line of Swatch watches.

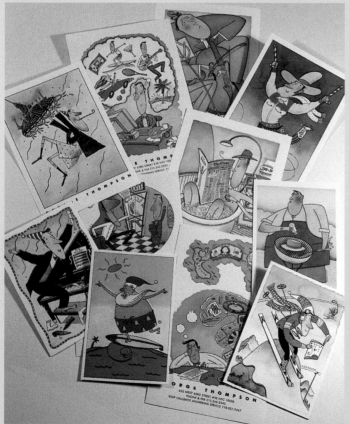

The Thompsons develop different promotional campaigns. George sends out individual postcards on a regular basis.

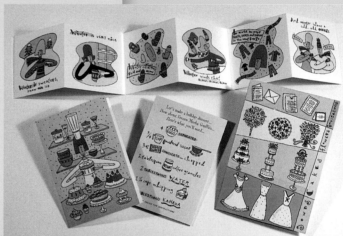

Emily's promotional mailings tend to be more elaborate foldout pieces that include a narrative.

4

SET UP YOUR WORK SPACE

Whether you're operating from your dining room table or planning to convert a significant portion of your home into a studio, you need to have space in your home that will help you work efficiently and without distraction. This chapter will help you determine where you should set up your studio and how you can present a professional image to the outside world. —→

Be Accessible

You need to be as accessible to clients and vendors as any other business or professional would be. In fact, as a home-based business, your advantage over your nine-to-five competition may be your accessibility outside traditional business hours.

But, unlike working in an office environment where others call on your clients, handle your mailing and shipping needs and make pickups and deliveries, you'll run these errands yourself. That means you won't be sitting by your phone to answer calls like you might have been before you were self-employed. You'll need a system to field your calls or make you accessible while you're out of your studio. You'll also need to take calls while you're on another line and ensure that you can receive calls while you're engaged on the computer or sending or receiving faxes.

Let's look at what it means to be accessible and what your basic equipment needs are to achieve accessibility.

✴ **Phone, fax and modem lines.** You'll need to set up a situation where personal calls won't interfere with your business calls and phone calls won't interfere with sending or receiving faxes or with use of your computer modem.

If you're in a household where roommates or family members share your residential line, an extra phone line for your business is a must. Even if you live alone, you should invest in at least one other line for your busi-

ness. For a minimal investment, you can hook up your business line to an answering machine with your business message and hook up your fax machine and modem to your residential line. The worst thing that can happen is that you'll miss a personal call when you're online or faxing someone. Of course, the optimum arrangement is to have four phone lines: one for your residence, one for your fax, one for your modem and one exclusively for business calls. Invest in what you can afford to do business without interruption.

Installing an extra line involves paying a onetime installation charge plus an additional monthly rate. An extra residential line will cost you less than a business line, but you can deduct the cost of a business line from your taxes. A business line also entitles you to a business listing in your local telephone directory. Many professionals feel this advantage makes a business line well-worth the extra investment.

✴ **Voice mail.** Most local telephone companies offer voice mail service for less than ten dollars a month. Private companies in many parts of the country offer voice mail service as well.

✴ **Answering machine.** If you don't purchase voice mail through your local phone company, an answering machine can field calls that you can't answer while you're on another call or out of the office. Your answering

Maintain a Professional Image

Today's business environment is a virtual entity. The people who buy products and services don't care if we work from home or office as long as we give them what they want when they want it and they can reach us when they need to. If you think about it, that makes your home an optimum place for doing business. Your clients can reach you anytime they want, twenty-four hours a day (although you'll probably want to switch on the answering machine when you need some sleep!).

In today's virtual business world, the "shingle" that once hung in front of a business establishment has been replaced by the impression people have of your business when they contact you over the phone or via the Internet. That's why it's important to present yourself as professionally as possible in these venues.

machine message should let callers know whom they've reached and how to leave a message, as well as other options for contacting you—numbers for your fax, mobile phone, pager or another line.

Answering machines are available as independent units or as units combined with a phone or fax machine.

* **Fax capability**. Fax technology comes in multiple forms—a freestanding machine or a card and software that can be installed in your computer. Computer faxing allows you to fax documents directly from your computer, eliminating the need to print out a paper copy for faxing. However, computer faxing won't let you fax things that aren't generated on your computer unless they're first digitized by scanning.

Freestanding fax machines have a variety of capabilities. Depending on what you can afford, you can fax a few pages or as many as twenty pages at a time. In addition to phone/fax machines, you can purchase units that have answering machines installed or are combined fax/photocopy machines.

* **Mobile phones and pagers**. These are other options for staying in touch when you're out of the office. You may already have a mobile phone. If you do,

mention the number in a message on your answering machine or voice mail service, or invest in call forwarding to have your calls automatically routed to your mobile phone.

Some pagers cost less than mobile phones and allow callers to reach you by paging you through a unit that you carry with you. Offer this number to callers trying to reach you on your answering machine or voice mail service. When they call the pager, they enter their phone number. After you see the number on the pager screen, you can call them back. Some pagers will also receive voice and/or e-mail messages.

* **Additional phone services**. You may want to invest in call waiting to be sure you don't miss incoming calls while you're engaged in a phone conversation. If you can't afford to or aren't able to install more than one phone line, call waiting is essential. Call waiting is a minimal investment, costing less than ten dollars per month in most areas.

If you install an extra line or have a mobile phone, call forwarding is also a worthwhile investment. You can use call forwarding to send your incoming calls to another telephone number, even your mobile phone, when you're out of the office.

[Your Perfect Home-Based Studio]

Establish an Online Presence

Welcome to the third millennium. Now that you've arrived, don't think for a minute that you can conduct business without being able to send and receive e-mail. If you're still wondering whether or not you should get online, stop wondering and do it.

At the time of this writing, your least expensive option for sending and receiving e-mail is a site called Hotmail (www.hotmail.com). You need a Web browser, such as Netscape Navigator, to access this site. If you want more e-mail options, Internet service providers (ISPs) offer perks along with Internet browsing capabilities, such as online address books and access to chat rooms. Some of the best-known ISPs are America Online, CompuServe, Prodigy and EarthLink.

Many local phone companies also offer Internet service.

Of course, none of these options establish an online presence for your business like your own Web site. If you plan to establish a Web site, one of the first things you should do is register a domain name for your business. InterNIC Registration services (www.internic.net) registers domain names and maintains a database of existing names with a *.com* ending. InterNIC will do a search of its database for the Web site name you'd like to use to ensure the same name isn't already in use.

Even if you don't establish a Web site right away, register a domain name as soon as possible to be sure the name will be available when you're ready to launch your site.

Living Space vs. Business Space

➤ Where you establish your work space in your home should be based on what you can afford to relegate to a work area, how necessary it may be for you to isolate your work space from other distractions and what your personal preferences are for a work environment.

Most professionals working out of their home will tell you that you need to have adequate space that's free of distractions for doing your work. This is no problem if you live by yourself. You control the space and the amount of distractions in it, so if you to choose to convert your living room into a studio, that's your call. Move the TV and VCR into your bedroom or kitchen.

Many professionals who work at home advise that the way to be most productive is to totally separate your work life from your home life—do all of your work from your work space with the door closed. I don't agree with this. Although I found that I need to close the door when I absolutely can't deal with distractions, I also found that being able to integrate my personal life with my business life is what makes working at home most appealing to me. I enjoy being accessible to my son (who's old enough to understand that I'll be with him in a minute if I'm on the phone), and I often do business phone calls while I'm making the beds, folding laundry or doing other quiet chores around the house.

The most important thing you need to consider is creating an office environment that will give you privacy when you need it. Even if you have to take over a closet, try to set up a work space where you can close the door. Why? Obviously to shut out distractions in your home environment, but also to create a physical barrier between you and your work. When you're done for the day, you can more easily leave your office and your work behind— out of sight, out of mind. Otherwise, you may constantly be nagged by the idea of finishing unfinished projects. Even a helpless workaholic needs to take a break! Don't set up your work space in the corner of your bedroom where it will face you every morning.

Deal With Children

When you set up your work space, keep in mind that it's easier to make your studio "kid proof" than to maintain an environment that's totally off-limits to your kids. Place dangerous equipment, things you need to return to clients and other things that need to be kept away from children in areas they can't reach or get into.

The other problem you'll encounter is dealing with business while satisfying your child's need to interact with you. With small children, it's absolutely impossible to totally divorce yourself from them while you work. You can't leave them unattended by closing the door and locking them out of your work area. It's best to maintain an open-door policy. You can often occupy them with computer games or other activities that will hold their attention while you're working.

If you don't get much done (and you probably won't!) while you and your child spend time together in your home studio, schedule your quality creative time, errands and meetings for times your children are in school or day care. Be there for them when they're home; then if you need more work time, work while they're napping, occupied with someone else or asleep for the night.

Be careful not to engage in phone calls—if you can help it—while your child is within earshot of the phone. Small children will nag, beg for your attention and ultimately cause you to interrupt your call, leaving the person on the phone to wait. This shows a prospective client that you're more preoccupied with your home life than you are with your business.

Finally, never, never take a child with you on client calls. As a mother and former art director, I can sympathize with both sides. But other designers and illustrators in similar situations confirmed my instincts: bringing your child with you into a professional situation, particularly where you're trying to win over a new client, immediately establishes the impression that your home-based business is a sideline that takes a backseat to your role as a parent. Children in this situation usually distract you from listening to your client and concentrating on his concerns, needlessly wasting his time. Clients may also conclude that if you can't find anyone to take care of your child during a meeting, you won't be able to do so during the time you need to get their job done. Schedule all business calls for a time when you can find someone to take care of your child.

Create the Right Environment

If possible, establish your work space in an area with a window so you can take advantage of natural light. Color viewed in incandescent lighting appears warm and yellowish; viewed in fluorescent lighting it appears cool and blue–green. An ideal lighting situation combines both. Many clamp-on and hanging fixtures available from designers and artists supply stores provide this balance with a circular fluorescent tube surrounding an incandescent bulb. However, the best means of judging color is by viewing it in daylight.

In spite of its color-viewing benefits, daylight can create a glare on computer monitors. Place your computer where it won't be hit directly by sunlight, or install window shades or drapes to shield your computer screen during peak daylight hours.

If you work with traditional media, the lighting directly over your work area should be two- to two-and-one-half times brighter than that in the rest of your work space. When working in a well-lit environment, consider using a black matte work surface to cut back on glare.

Also keep in mind that your work space must make you feel like a professional and provide a comfortable and pleasant work environment. As a visual person, you'll want an atmosphere that appeals to your visual senses. Although I'm surrounded by bookshelves and computer equipment in my small office, the wall of windows in my studio is my "eye candy." Whenever I need a break, I can wave at neighbors and watch the world go by. You may be satisfied with hanging some pictures in your office, or you may want to paint your studio walls a favorite color. Whatever you do, try to make the work space in your home inviting as well as productive.

CASE STUDY | # Home Office Supports Parental Priorities

WHEN SHE WAS HIRED AT HER LAST FULL-TIME JOB, TRICIA RAUEN OF TREEHOUSE DESIGN LET IT BE KNOWN THAT SHE WANTED EVENTUALLY TO BE A MOM, working out of a home-based studio. "My former employer and I have a great relationship," says Rauen of Tom Haskins, whom she worked for at Los Angeles-based Buz Design Group. "He always knew that was my long-range goal because I was very clear with him upfront."

Rauen's desire to combine parenting with her own home-based design business started to emerge after she married Stan Evenson, principal of Evenson Design Group, in 1995. "My priorities started to change," says Rauen, who found herself thrown into family life as stepmom to Evenson's two children. "I had always been a hard worker and put in many late hours to get the job done, but I got to a point where that wasn't balancing well with my new situation." After reevaluating her priorities and deciding she wanted more flexibility in her life, Rauen made it clear to her former boss that her days at Buz Design Group would end when she was ready to have a baby.

While Rauen was working at Buz Design Group, she and Evenson started hunting for a home that included space she could eventually use as a home studio. They found a house, built on a hillside overlooking Los Angeles, that included an office. "The office is built underneath the house, into the hillside," says Rauen. Although the office was an ideal location for Rauen's design business, it remained largely unused as a studio after Rauen and Evenson moved in. In fact, it served as a temporary kitchen while their new home's real kitchen was being remodeled.

Toward the end of her four-year stint as creative director at Buz Design Group, Rauen made known she was planning to get pregnant. When she found out she

TREEHOUSE DESIGN

"I didn't start to set up the office until I was pregnant. I was painting it just days before I delivered the baby."

TRICIA RAUEN

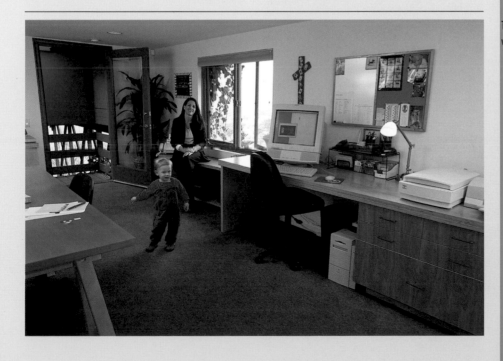

Tricia Rauen in her studio with son Jack.

was expecting, she immediately set about converting the office into a studio that would function as the base for her design business. "I left Buz Design in the ninth month of my pregnancy," says Rauen. "I was painting the office just days before I delivered the baby."

Baby Jack was born July 21, 1998. After giving birth, Rauen eased herself back into working as a full-time graphic designer. "It was hard to get motivated the first few months. My energy level was really low," says Rauen. Things started picking up over time as Rauen's stamina improved. "Lately I've been working almost full-time," she relates. "I've gotten that drive and energy level back full force, and I like that. I like being busy."

Rauen has a full-time caregiver to help take care of Jack and the other two children. Because her studio is built beneath the house, she has the convenience of working at home with the privacy of a separate location. "When you walk out onto the back patio, there's a stairway that goes down to the office,"

she explains. "When I go to work, I'm actually leaving the house." Her one-room home space includes a bathroom, refrigerator and three phone lines: a work phone, a dedicated fax/modem line and the residential line that runs to the home upstairs. "I have a beautiful view of Los Angeles, with draping ivy across the windows and lots of light," she relates. Because of its hillside location, she chose the name Treehouse Design for her business.

Because Rauen spent a year easing herself from full-time mother into both full-time designer and mother, she hasn't needed to go after work—it has come to her gradually as she has been able to

STUDIO EQUIPMENT

Computer	Apple Power Mac G3
Color Printer	Epson Stylus Color 1200
Black-and-White Printer	Hewlett-Packard LaserJet 5000
Scanner	UMAX Powerlook II
Photocopier	Ricoh tabletop

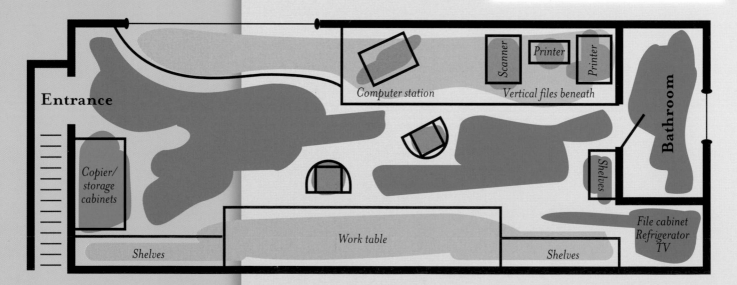

Entrance

Copier/ storage cabinets

Shelves

Work table

Computer station Vertical files beneath

Scanner Printer Printer

Bathroom

Shelves

File cabinet
Refrigerator
TV

Shelves

[Your Perfect Home-Based Studio]

handle it. "Those who have known that I started my own studio have introduced me to potential clients," she states. However, she wants to continue her recent full-time routine. "My goal is to work steadily and once in a while take time to take my son to a class or meet someone for lunch, or do some of those personal things that I normally couldn't find the time to do while working full-time at a larger firm," says Rauen. "I'd like to make that part of my schedule but still put in a forty-hour work week and successfully balance parenting and my graphic design business."

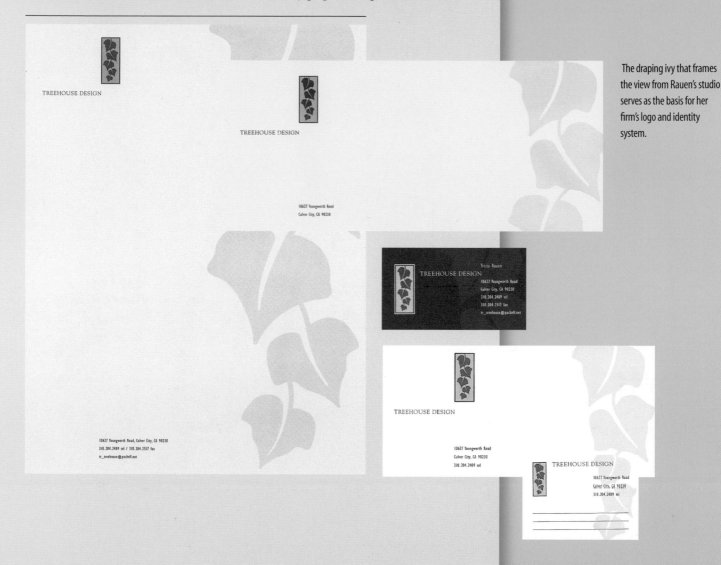

The draping ivy that frames the view from Rauen's studio serves as the basis for her firm's logo and identity system.

Rauen specializes in identity, collateral and packaging design. Since establishing Treehouse Design, she has developed several identity programs. Her work has included logo and stationery design for izyx, an e-commerce company serving the dental industry; logo design for Ascension Entertainment, a film production company; and logo and trademark design for On the Spot Activewear, a line of children's clothing.

Some of Rauen's identity projects have generated additional work. Her logo work for Maria Physical Therapy led to designing supplementary business materials, including a promotional brochure.

54

5

Once you've established which area of your home will serve as your studio, you'll need to invest in furniture and equipment. This chapter will help you determine what you need and what type of physical arrangement works best. It will also help you find the best deals on equipment purchases and leases.

FURNITURE AND EQUIPMENT FOR YOUR STUDIO

Furniture

You'll need plenty of flat surfaces to hold computers and other equipment. You'll also need them for spreading out and viewing your work and organizing projects.

If you can't afford to buy a lot of furniture, an old table or a hollow-core door placed across two sawhorses will do as a surface for working and supporting equipment, but your computer should be housed in a desk or hutch designed specifically for computers. Computer desks and hutches with retractable keyboard shelves are not only more efficient, but they're also more likely to place your mouse and keyboard at ergonomically correct levels. You don't need to spend a lot of money; many office supply stores sell computer desks for less than one hundred dollars.

Along with a hutch or desk for your computer, you'll need a chair. If you can't adjust the height of your computer, an adjustable chair is essential. When you're seated, your computer mouse and keyboard should be at the same height as your bent forearm. A chair with wheels will allow you to roll from one workstation to the next.

In addition to flat work surfaces, you'll need storage: drawers or cubbies for storing small items such as pens, pencils, tape, diskettes and other miscellany; file cabinets for organizing records and other printed information; shelves for reference materials and stacks of letterhead and other printing papers; and flat files for storing visuals from past projects and/or art boards. (A flat file also makes a great tabletop work surface.)

Major retail office supply chains and furniture stores are often your best bet for purchasing computer furnishings, chairs and file cabinets. Flat files usually need to be purchased from companies specializing in art and drafting supplies.

[Your Perfect Home-Based Studio]

Make the Most of Your Money

For those who want to stretch their dollars, many furniture stores and other retail outlets offer a one-year-same-as-cash or no-payment-for-a-year deal. Both arrangements are a boon for start-ups anticipating improved cash flow after their business is up and going.

The one-year deal will require you to make monthly payments, allowing you to purchase everything you need for as little as one hundred dollars a month. But be sure you pay everything you owe within a year, otherwise the interest on the remaining balance is likely to be an exorbitant 20 to 21 percent.

The no-payment-for-a-year deal lets you defer payment for a year. Stores offering this expect to make money from unassuming consumers who don't pay in full at the end of the year and must pay the high interest on the unpaid balance for every month following the payment due date. Avoid this by putting money aside every month to cover this bill when it's due.

If you pay on time, both of these options will be less expensive than putting your purchases on your credit card and paying high interest on any balance.

A computer hutch and matching file cabinet from Reliable HomeOffice.

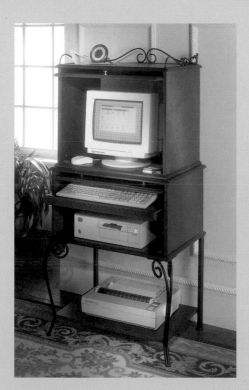

The Importance of an Ergonomically Correct Workstation

Shortly after I started working from my home, I developed a tingling sensation in my hands—an early symptom of carpal tunnel syndrome. After asking others what they did to remedy this problem, I decided to purchase a keyboard support pad—designed to support hands and wrists—from a local office supply store (for under twenty dollars).

Correct posture and support for your back, arms and wrists is extremely important. You may be able to work on a temporary basis in a situation that's not ergonomically correct, but it will eventually catch up with you. In the long run, you'll need a computer station setup that's suited to your height and body proportions.

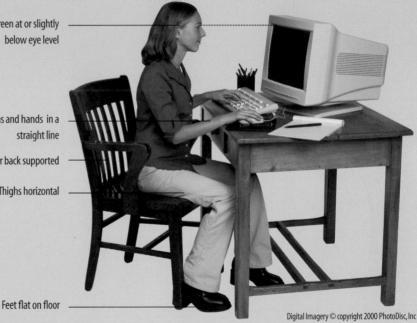

Top of screen at or slightly below eye level

Forearms and hands in a straight line

Lower back supported

Thighs horizontal

Feet flat on floor

Digital Imagery © copyright 2000 PhotoDisc, Inc

An ergonomically correct workstation should allow you to sit in front of your computer with your keyboard and mouse at the same level as your bent forearms.

Arrange Your Furniture and Equipment

Experts advise a U-shaped configuration for setting up the tools and equipment you'll need to access most of the time. A U-shaped workstation gives you easy access to your work environment and also allows you to handle your responsibilities without repeatedly getting in and out of your chair. Having all tasks at arm's length reduces wasted time and energy.

You can have this kind of efficiency in an area as small as a 6' × 7' (1.8m × 2.1m) cubicle. The strategy to make it work is to assign a task area to each segment of the U-shaped space art/design, administrative and reference.

If you're right-handed, place your drafting table, desk or other work surface to the left, against a wall, with space to pin-up drawings and other notes directly above. Your computer workstation should be to the right of this table, in the corner of the U.

Your administrative tasks should be placed to the right of your computer workstation. This area should house your phone, your address file and vendor information, and possibly a fax machine. Use the space directly above your administrative area to position a calendar and/or bulletin board where you can post business cards and other reminders. This area can also be used for shelving. Place the reference material you need to access most frequently here. The space below can be used for file cabinets and additional shelving—even a refrigerator.

Designate the area to the right of the administrative area as an additional work surface for a light table or other needs, such as additional reference materials. Use the area above this as a pin-up area.

You'll probably want to commit a lot of vertical surface above your workstation to pin-up space. This will allow you to surround yourself with visual reminders of all of the projects at hand.

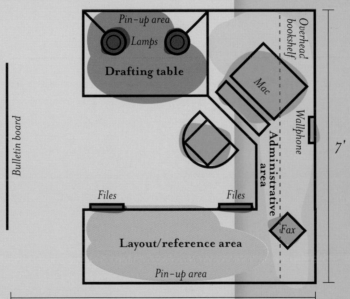

A U-shaped arrangement of your telephone, computer and other equipment—as well as information you frequently need to access—is most efficient because it puts everything within easy reach.

Computer Equipment and Other Big-Ticket Items

➤ Your start-up purchases will be dictated by what you can afford and what you need to do your work. To get started, these are the musts:

✳ **Computer workstation.** The power and memory requirements depend entirely on what kind of work you do. If you do traditional illustration, you won't need a sophisticated setup—just a com-puter for Internet access and word pro-cessing. If you produce your work on the computer, you'll need something more substantial and possibly two workstations.

✳ **Printer.** If you'll print out only such items as invoices, purchase orders and correspondence, a black-and-white printer will do. But if you need to gen-erate comps, you'll need a color printer. Getting color comps produced at a service bureau will quickly drain your budget.

 With less expensive color printers, or those that generate prints at a high speed, you may sacrifice color quality. Also consider what size paper your printer will accommodate and whether or not 60-pound (89 gsm) text paper can be fed through the printer just as easily as copier bond.

✳ **Scanner.** Even if you're an illustrator working in traditional media, you'll probably want a flatbed scanner so you can digitize your work and e-mail your concepts to your clients. If you work with transparencies, slides and photos, you'll need either a flatbed scanner with a slide adapter or a scanner that scans flat art, transparencies and slides.

✳ **Photocopier.** If you have a limited need for photocopies, you can generate copies from a fax machine or purchase a combination fax/photocopier. If you need to make black-and-white photo-copies on a regular basis, tabletop pho-tocopiers are usually sufficient, and they're less expensive—generally starting at about three hundred dol-lars—than freestanding models. If you need to make color photocopies, you can purchase equipment that will scan, make color photocopies and gen-erate color prints.

✳ **Software.** Remember to purchase and install software. When you purchase equipment, know what programs come installed or bundled with what you're buying. You probably have a good idea of what you need, but here's a list to remind you of some of the basic functions you'll want to do on your computer:

 Page layout
 Photo editing
 Illustration
 Word processing
 Internet browsing
 Scanning

Shuttle and Store Computer Files

You can transfer files from one computer to another within your studio through your network. You can also send files to others by e-mailing them. However, sometimes you'll need to send computer files via mail or courier. You'll need a means of sending these files as well as storing your files in case something goes wrong with your computer. In addition to backing up current projects, you should also archive past jobs so they don't rob your computer of memory. Here's an overview of your options:

* **Diskettes.** The least expensive means of transferring and storing files are the square diskettes that people have been using for years. They store up to 1.4 MB, which is about enough for image files, text files from a word processing program or a small layout program. If you have a program such as Aladdin StuffIt, you can compress larger files to fit on a diskette. PCs and older Macintosh (Mac) computers have built-in diskette drives, but newer Macs don't—they require external diskette drives. Because of their limited storage capacity, diskettes are an impractical option for backing up or archiving files.

* **Zip and Jaz Disks.** One of the most common means of shuttling and storing digital files is on Zip disks. Some computers come with Zip drives installed. For computers that don't have a built-in Zip drive, an external one is necessary. With a storage capacity of 100 MB per disk, Zip disks are usually adequate for storing as well as shuttling all kinds of jobs. Jaz disks are a more expensive option, but they have a significantly larger storage capacity—up to 2 GB. Jaz drives are available for PCs and Macs.

* **CD-ROM.** CD-ROM drives have been a standard fixture in most computers for several years, meaning that CD-ROMs can be universally read by practically all computers, except for old models. CD-ROMs don't have to be formatted for a Mac or PC like Zip disks and other diskettes. CD-ROMs can also hold a lot of information, typically up to 650 MB, making them ideal for storage.

* **External drives.** For backing up and archiving only, you can purchase additional drives for your computer. Most external drives have a capacity of about 20 GB.

Get the Best Deal on Computer Equipment

➤ First you must decide whether you want to work with new or used equipment. Because everybody is constantly upgrading, some of the best deals on used equipment may come from a former employer, a school or an individual who's upgrading to a newer system and wants to unload a current system. If you're familiar with the user, you're more likely to get an honest assessment of what you're purchasing and strike a deal that's mutually agreeable.

You can also find used computer equipment through advertisements in the classified section of your local paper. This way you can get the lowest possible price on equipment that may not be state-of-the-art.

Another resource for used Mac equipment is MacSales. In addition to selling used equipment, MacSales also buys used equipment, does repairs and sells parts. Contact them at (888) MACSALE or www.macs4sale.com.

If you want to purchase new equipment, mail-order houses offer some of the best deals. Some of the largest mail-order houses offering Macintosh equipment and a range of compatible peripherals and parts are MicroWarehouse (800-255-6227 or www.warehouse.com), Mac Zone (800-248-0800 or www.maczone.com) and ClubMac (800-217-9208 or www.clubmac.com). For PCs and compatible peripherals try Computer Discount Warehouse (800-716-4239 or www.cdw.com).

If you're a college student or teacher, university bookstores are a great place to purchase computers at a discount. Teachers on the high school or elementary level also have access to educational discounts, offered by manufacturers, that other professionals aren't eligible for.

When evaluating your purchase options, consider the technological expertise you'll need to set up your computer station and network it with other equipment or computer stations in your studio. Some local retail outlets will provide installation expertise, whereas mail-order sources and providers of used equipment are unlikely to afford you this opportunity.

Get the Technological Expertise You Need

Since starting my home studio, one professional I've come to rely on most is my computer technician. He helps me upgrade and install new equipment, keeps me networked as I add other stations and equipment to my system and has provided me with advice and expertise on how to most effectively maintain an online presence. He's also been my Mac repairman. Whenever something goes wrong, I call him.

I've tried walk-in computer service centers affiliated with computer retail centers in my area that claim to do repair work; I've found them to be totally inadequate. The growth in the industry and tight job market have clearly affected the expertise level of the personnel these outfits hire.

Find someone who is willing to come to your home, open the casing on your computer and other equipment and run lines all over your studio—whatever you need to get your system up and running. Such people aren't likely to be listed in your yellow pages; find them by asking other professionals in your trade.

The technician I currently use charges seventy-five dollars per hour, but he's worth it when I consider that my local computer dealer charges a minimum of thirty-five dollars for a diagnosis that is often inaccurate. When I factor in the cost of my time spent hauling my equipment to a dealer, the seventy-five-dollar fee becomes a real bargain.

Should You Lease or Buy?

In many areas, you can lease your computer equipment through computer dealers as well as companies that specialize in leasing and servicing and training individuals to use their equipment.

Most leasing services offer an arrangement where you pay a monthly fee at an agreed-upon price over a specified period of time, and at the end of that period you own the equipment. Lease arrangements can generally be negotiated for a one- to four-year period.

To locate computer leasing services, ask colleagues or consult listings in your local business-to-business phone directory.

If you're relatively inexperienced when it comes to working with and installing computers or if you're setting up a new business and you're in a financial bind, leasing may be a good option. It may not be a good idea if you know how to install your computer system and equipment, you've found some bargains on equipment or you're setting up shop with used or donated equipment. Equipment lessors know how to install a system of products they're familiar with. They may not know how to effectively integrate other used equipment into a network.

Here are some leasing specifics to help determine whether or not leasing is for you:

* Instead of making a large initial capital investment in equipment, your cash outlay will be spread out over a long period of time. If you need to make additional purchases to set up your business, you will be able to do so.

* Monthly lease payments are tax deductible.

* The outfit you lease from will install the equipment and software and set up your network.

* The lessor will show you how to use the equipment. (You'll get a quick run-through, not a course in desktop publishing!)

* The lessor will maintain your equipment. If something goes wrong, he foots the bill and takes responsibility for making it right.

* You can easily upgrade by trading in your current equipment for the most recent model.

* You need to insure leased equipment for its full value. In fact, you'll need to show proof of insurance before you sign your lease contract.

* By the time you've paid off the lease and you own the equipment, it will likely be obsolete.

CASE STUDY **Big Isn't Necessarily Better**

> *"This is as packed as it gets."*

MARK ANDRESEN

With equipment and resources stacked floor-to-ceiling, Andresen makes the most of his 9' x 12' (2.7m x 3.7m) studio. Illustration by Mark Andresen.

N EW ORLEANS-BASED ILLUSTRATOR MARK ANDRESEN HAS SPENT THE PAST TWENTY-FIVE YEARS PURSUING A CAREER THAT HAS EXPOSED HIM TO MANY AREAS OF the graphic arts and taken him all over the country. For many years, he concentrated on editorial design, serving as art director of *Atlanta* and *New Orleans* magazines, among others. Magazine art direction introduced Andresen to freelance editorial illustration, which he found himself increasingly turning to for the additional income and creative opportunity it afforded.

After he left *New Orleans* magazine in 1988, Andresen decided to totally devote

himself to working as an illustrator. Operating out of a converted bedroom in his New Orleans home, Andresen describes his studio as "very small." Says Andresen, "It's about the size of a large Persian rug.

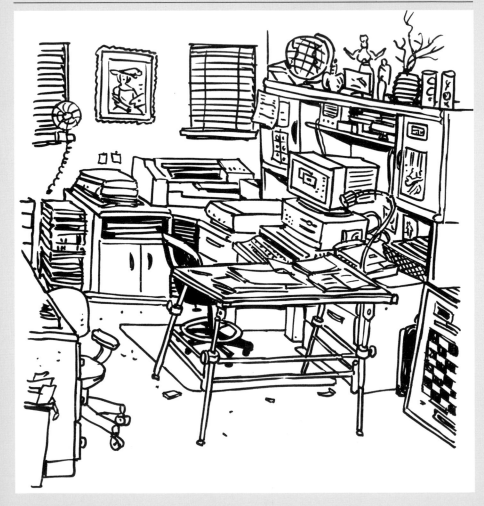

[Your Perfect Home-Based Studio]

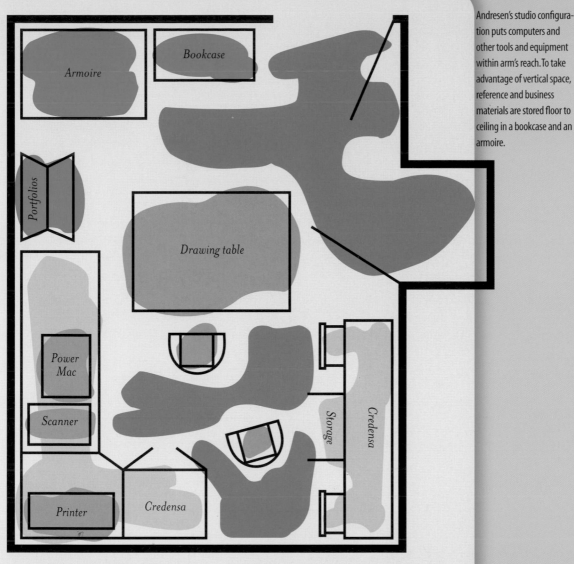

Labels within diagram: Armoire, Bookcase, Portfolios, Drawing table, Power Mac, Scanner, Printer, Credensa, Storage, Credensa

Andresen's studio configuration puts computers and other tools and equipment within arm's reach. To take advantage of vertical space, reference and business materials are stored floor to ceiling in a bookcase and an armoire.

If I'm not doing billboards by hand, it's comfortable."

In spite of his small studio, Andresen commands big-time commissions—his name is well known by clients and design professionals all over the country. Although local clients make up a percentage of his work, much of Andresen's illustration revenue comes from artists representative Susan Wells & Associates, which brings him assignments from clients such as First Union Bank in Atlanta and Becker Multimedia.

Andresen has made the most of the space he has. Every inch of his studio, from floor to ceiling, is utilized with shelf upon shelf filled with resources. "I've got a closet in here," says Andresen. "It's as packed as it gets. If you open the door, it's one solid wall of paper." When it comes

STUDIO EQUIPMENT

Computer	Apple Power Mac 7100
Color Printer	Epson Stylus Color 1520
Scanner	Epson Expression 636

to expanding, Andresen doesn't. "I still buy CDs, which I jam next to my CD player, but other than that, I throw things away," he explains. "I get a garbage bag and edit. Somehow, the amount of stuff in the room stays the same."

Andresen's work space demonstrates that you don't necessarily need to have a lot of space to get your work done. In fact, his studio setup is as efficient as it gets. A U-shaped configuration puts everything he needs at his fingertips, allowing him to easily accomplish several tasks simultaneously. "I can be working at my drawing board and talking on the phone and working on the computer at the same time, with no more than a spin of the swivel chair," he relates. When he needs a

break from the confines of his studio, Andresen often ambles into other rooms of the house and even outdoors into his backyard with his drawing materials.

Andresen could afford to move out of his home studio into rented space, but he chooses not to. "I don't want to do the traveling thing," he states. "With my home studio, I'm here at six o'clock or seven o'clock in the morning." Andresen also feels he has more control over the situation as his own landlord. "Someone I know just got booted out of his building because they're turning it into a hotel," he says. "The few people I've seen who have made the transition from working out of their home to an outside studio have just added an additional expense."

Andresen is also known for designing the typeface Not Caslon for Émigré. His font has been widely recognized and was featured in the book *Faces on the Edge* by Steven Heller.

Andresen's self-promotion illustrations reflect his ability to master a broad range of media and stylistic approaches (left and opposite page). His work has brought him success in illustrating for a client roster that includes local and national entities, from the Neville Brothers to First Union Bank to HGTV.

66

6

MONEY MATTERS

✻ Running a home-based studio can be an expensive proposition. It's important to develop a financial plan and a method of keeping track of income and expenses so you'll know how to most effectively manage your money. It's also necessary to get a handle on how much money you'll need to purchase the necessary equipment and provide income while you're getting established and to determine where this money will come from. ⟶

What Are Your Operating Expenses?

In order to determine how much money you'll need to operate your business, you'll need to figure out what your ex-penses are on a monthly basis. Start by breaking down your expenses into two categories: (1) start-up costs and (2) fixed and variable expenses.

Start-up costs include equipment purchases, installation charges and other expenses you'll incur (or have incurred) to establish your business. I would advise paying for these costs in your first year of business so they'll be included in your first year's operating expenses. Divide the sum of your start-up costs by twelve so you'll know the monthly cost of your start-up expenses.

Fixed and variable expenses are what you incur to run your business on a regular basis. Fixed expenses include items such as lease charges, phone service, insurance and any other costs you have that are the same each month. Some professional services also need to be factored

into this. For instance, if you pay your tax accountant the same fee once every year, average in his fee by dividing it by twelve.

Variable expenses are costs whose amounts will differ week to week. They include supplies, shipping and postage, transportation and entertainment. Factor annual expenses into this figure as well. For instance, if you'll be attending a conference in another city, calculate what it will cost to do this and divide the cost by twelve. Don't include items that you'll bill to your client, such as printing or job-specific charges like photography.

Finally, add to this list your salary—what you need to make monthly in order to cover your personal expenses. After you've made your list, compute the total; this is the minimum you'll need to earn on average each month in order to make your business viable. Use the model on this page as a guide for determining your expenses.

Formula for Determining Your Monthly Business Expenses

Salary	$3,000
Equipment purchases* ($24,000÷12)	2,000
Shipping/postage	50
Phone	20
Professional fees	25
Insurance	200
Travel expenses	40
Meals/entertainment	60
Equipment maintenance	20
Supplies	25
Total	$5,440

*This start-up cost would be included in the expense calculation for your first year of business.

Determine What You Need to Earn

➤ After you've figured out what your monthly expenses will be, divide this figure by four to determine what your weekly expenses will be. If you work an average of forty hours per week, divide this total by forty. This will give you an idea of what you'll need to earn per hour to cover your business expenses, including the personal income you need.

Apply this formula to the model shown:

Total monthly expenses (first year)	$5,440
Total weekly expenses	$1,360
Expenses per hour	$34

This hourly rate represents the absolute minimum rate you must charge for your time. In fact, you'll want to aim for billing your clients at least 20 percent more than this. If you need to make thirty-four dollars per hour just to make ends meet, you should also factor in slow periods where you may be busy only twenty or thirty hours per week. In addition, this amount does not include consideration of time spent on administrative tasks, lost time due to sickness, time spent seeking clients or time off for a vacation or conference. Nevertheless, this minimum hourly rate is in the ballpark of what you'll need to earn to stay afloat.

[Your Perfect Home-Based Studio]

Determine What You Should Charge

More than likely, you bid for jobs by quoting your clients a price per project, not an hourly rate. Keep in mind that what you charge for a job will vary depending on the client and the nature of its business. Advertising illustration, for instance, usually pays on a higher scale than editorial illustration. Nonprofit organizations usually have tighter budgets than businesses operating for profit. Large corporations are likely to pay more than small businesses.

What you charge will also be determined by the tasks involved. For instance, the importance of an identity and the extensive conceptualization involved in developing one should command a higher fee than doing the layout for a flyer.

When you're bidding on a job, estimate how much of your time you'll need to get it done. If it looks as though it will take ten hours and your minimum hourly rate is thirty-four dollars, quote a charge of five hundred dollars. Conversely, once you're involved in a project, keep your minimum hourly rate in mind and keep track of your time. If you've quoted the job at five hundred dollars, try to limit your time to ten hours. This will bring your actual hourly rate up to fifty dollars.

Although it's important to charge your clients enough to support yourself and cover your business expenses, the bottom line is that you must charge your clients a competitive rate in order to get their business. This is where your experience and assessment of the market value of your work become important factors. If you're not fully aware of what a fair rate would be for a particular project, do your homework to find out. Ask friends who have done similar work what they have charged. You need to set a price that's fair and competitive. An inflated price could cause you to lose a job, while one that's too low may give the impression that you're a novice.

Finally, don't forget to include in your quoted charge any job-specific expenses you think you might incur in the process of completing a job. If you bid on a poster job that includes a photo and you figure five hundred dollars should cover your time in designing it, don't forget to add the cost of the stock photo to your total quoted price for the job. Purchasing outside services also entitles you to a markup that you should pass along to your client. The industry standard is 15 to 20 percent to cover your time and trouble in handling this expense. If the stock photo for the poster job costs one hundred dollars, add this plus another fifteen to twenty dollars to your base fee in your quote.

Will Your Income Offset Your Expenses?

Figure Your Net Worth

You'll need to know your personal net worth if you want to apply for a loan. To determine your net worth, total your assets and subtract what you owe (credit cards; mortgages; car, personal or business loans; brokerage house margin accounts).

Here's how to calculate your assets:

* **Bank accounts.** Use the total from your most recent bank statements.

* **Mutual funds.** Use your most current mutual fund statement. Deduct any redemption fees.

* **Stocks.** Consult a newspaper to get the current value per share of your holdings. Deduct any redemption fees.

* **Treasury bills and notes.** Check the current value of what you own by calling (216) 522-4012 or by visiting the Web site at www.savingsbonds.gov.

* **Certificates of deposit.** Subtract penalties and interest loss from the total if you were to cash one in today.

* **IRAs, Keogh, 401(K) or tax-deferred annuities.** Use the total from your most recent statement.

* **Tax-exempt municipal and state bonds.** Because these are almost always held to maturity, calculate their current worth at their face value.

* **Corporate bonds.** Value them as you would a stock if they're listed on a stock exchange. If your bonds aren't traded frequently, value them as if they were tax-exempt bonds.

* **Life or endowment life insurance policies.** Use the current cash value.

* **Real estate.** Use the current value of any investment real estate you own excluding mortgages or construction loans. (Including the value of your primary residence is also an option, but banks often don't consider this to be a real asset since, if it were sold, you would still need a place to live.)

➤ You have an idea of what your expenses will be, and you know what to charge per hour in order to cover these expenses. The missing components of the equation that will determine your business's viability are the source of your income and how much it will be.

Whether you're just thinking about going into business or you've been in business for years, it's important to get a handle on what your income will be for the coming year by making a list of who your current or potential clients are and what kinds of projects you can anticipate from them. This part is easy if you've been in business for a while or if you're under contract with a client to produce a project on a regular basis. But if your work is sporadic or unknown at this point, estimating your income may be more difficult. What-

ever your situation is, be realistic. Don't count on income if you're not certain of it. Err on the low side; underestimate what you think you'll make. You'll be better off this way because any surprises regarding your income will be pleasant ones.

From there, determine your expected revenues for the projects you anticipate in the coming year. How does this total compare with your operating expenses, including what you need to make as a salary? If your estimated income total falls short of what it will take to stay in business, rethink your plan—charge more for your time if the market will bear it or cut back on your operating expenses where possible. If you're in the planning stages, you may want to postpone launching your business until you've cultivated more business opportunities.

[Your Perfect Home-Based Studio]

Finance Your Business

Equipping a home studio with a computer, software, modem, printer, Internet service, scanner, fax and answering machine capabilities and basic furnishings is an expensive proposition, running close to twenty thousand dollars. Consider, as well, that because it often takes months to complete and get paid for your work, you may work constantly and do well, but find your business may operate in the red for the first several months. You'll need some extra money on hand to cover start-up costs and unexpected expenses, provide income while you get established, and smooth out the effects of income variability.

Experts advise that before you launch your business you build a nest egg that's the equivalent of six months of your business income (including the portion to cover your salary) plus whatever your start-up expenses are. Half of this should be completely liquid; the rest can be available in credit. However, if you have little in your savings, a loan may be your best option for covering start-up expenses. Here are some options:

* **Personal loans.** Sometimes personal loans are easier to get than business loans. If you (or your spouse) have an existing job and a good credit rating and you own your own home, you should be able to borrow 20 to 30 percent of your personal net worth. Small regional banks are usually your best bet for obtaining a loan and are more likely to offer you good service if you also establish your business account with that bank.

* **Home equity loans.** You can also apply for a home equity loan or line of credit. A home equity loan provides tax-deductible interest. A home equity line of credit is similar to a home equity loan: You borrow against the value of your home, but rather than borrowing a lump sum, you borrow what you need when you need it. Be sure to consider the implications of using your home for collateral—you could risk losing your home if your business goes belly-up and you have huge debts to repay.

* **Small Business Administration (SBA) loans.** The SBA exists to help all types of small businesses, making loans of up to $25,000. The money can be used to buy equipment and furniture but may not be used to pay existing debts. The SBA awards loans to businesses based on credit history, good character and commitment to making a business plan successful.

 To apply for an SBA loan or any other business loan, you'll need to put together a loan proposal. The proposal should include: your business plan (see "Develop a Business Plan," chapter two); copies of your tax returns for the past three years; a written request for the amount of money you need; an explanation of why you need it; and an itemized list of how this money will be spent.

For information on where and how to apply, call the SBA at (800) U-ASK-SBA or visit their Web site at www.sba.gov.

Keep Track of Income and Expenses

To meet the IRS's guidelines for record keeping, it's essential that you establish a business bank account to separate your business income and expenses from your personal finances. Establish a checking account with a balance that will cover your anticipated expenses over the coming months. Your check-writing privileges should cover about twenty checks per month. Also apply for a company credit card linked to this account.

You should pay all of your business expenses through this account, and you should deposit all of your business income into it. As your business income increases, you may also want to establish a savings account or money market account under your business name in order to take advantage of the favorable interest rates these accounts offer.

Next, purchase a disbursement journal or ledger book. Your ledger book will help you keep track of expenses and break them down in a way that complies with IRS guidelines for classifying deductible business expenses. The categories you'll need for your ledger book are as follows:

* **Supplies: equipment and furnishings**

* **Postage and shipping**

* **Meals and entertainment**

* **Travel**

* **Phone**

* **Professional services**

* **Dues, books and subscriptions**

* **Advertising**

* **Sales tax**

* **Equipment maintenance and repairs**

* **Petty cash**

* **Salary**

Record the date, amount, check number and payee for each purchase under each category. Petty cash covers expenses that you wouldn't write a check for, such as parking. Write a check to "petty cash" every month to cover petty cash expenses, and be sure to keep receipts for all petty cash expenditures. If you're ever audited, the IRS checks this category very carefully.

Most banks offer to their business customers checkbooks that include their own ledgers or disbursement sheets. These save you the trouble of entering this information in your checkbook and again in a ledger book.

Except for your petty cash receipts, your checks act as your receipts and your ledger book as your proof of your business expenses. Your ledger book also acts as a document for income.

When you're paid for a job, deposit the total payment into your business checking account and enter it in your ledger book. (If you need cash, don't deduct from your deposit; deposit the payment and write yourself a check for salary.)

Maintain Other Financial Records

For smooth financial sailing, you should pay bills when they're due and collect payments within your set terms. To do this, keep track of incoming bills from vendors and receipts of payments for invoices you've sent to clients.

The easiest way to keep tabs on what needs to be paid is to purchase an accordion file with thirty slots, one for each day of the month. For instance, if a bill is due on January 10, slip it into the "10" slot. Then pay off this bill, as well as the other bills in this slot, just before the due date. That way when you receive a bill due on February 10, you can slip it in the same "10" slot and begin the next thirty-day cycle. This method ensures that you'll pay bills on time but not until payment is due.

Keep track of payments you've received for work you've invoiced by maintaining two files: one marked "Paid" and one marked "Unpaid." When you issue an invoice, print out a duplicate and slip it into the "Unpaid" folder. When a client pays, note the payment information (e.g., receipt date, check number) on the invoice copy and move it into the "Paid" folder. If you receive partial payment on an invoice, start an additional folder marked "Partially Paid." These invoice copies should be annotated with the date and amount of partial payments and placed in this folder. When you receive the remaining balance, transfer the invoice to the "Paid" folder.

You'll also need to maintain a log of your business travel auto mileage. A notebook that you keep in your car to record the date, distance and where you traveled will do. You can also purchase special books for this at office supply stores. It's important to document your mileage and total it at the end of the year so that you can deduct this as a travel expense when you file your tax returns.

A Way Around the Paperwork

If you are a sole proprietor who runs a small business with minimal expenses to track, you may find that maintaining a ledger book is more trouble than it's worth.

It's possible to do away with the paperwork involved in maintaining a ledger sheet by using your receipts as proof of business expenditures. Be sure you have a receipt for any expenditure that you didn't write a check for and sort them according to the expense categories listed in "Keep Track of Income and Expenses." Hang onto them for not only the past year, but for many years. If you're audited, you'll need to show proof of your expenditures for the past seven years, not just the year in question.

CASE STUDY | A Low-Rent Studio for a Four-Person Design Firm

"There's no major overhead. That's allowed us to buy more of the latest technology."

CHARLY PALMER

TP Design partners Dorothea Taylor-Palmer and Charly Palmer.

"WE'VE BEEN A HOME OFFICE FROM THE VERY BEGINNING," SAYS CHARLY PALMER DESCRIBING TP DESIGN, THE FIRM HE CO-OWNS WITH FORMER WIFE Dorothea Taylor-Palmer. The firm began to take shape in 1991 when the couple decided to move to Atlanta. At that point, they had each accumulated fifteen years of experience working full-time in the Milwaukee area, but they felt there were more lucrative opportunities for work in Atlanta. "We wanted to be involved in some way with the [1996] Olympics," Palmer explains. The couple also felt Atlanta might be the place to form their own business. Their initial plan was that one of them would freelance while the other worked at a full-time job.

Eight weeks prior to moving, Palmer came to search for assignments and get established. After he showed their portfolio around town, it soon became evident that there was enough interest in the couple's work for them both to stay busy with freelance work. "It didn't take us long to build up a clientele," says Palmer. "We were fortunate enough to meet someone who helped us get in with some of the key art directors at Coca-Cola. We got some pretty decent-sized assignments within the first month or two."

Palmer and Taylor-Palmer originally settled in a townhouse apartment in Atlanta where they converted one room into a studio. But as the business grew, along with their fortunes, the couple found it necessary to purchase a house. In 1995, they found one that provided plenty of room for their growing business, just a thirty-minute drive from Atlanta in suburban Stone Mountain. "We wanted to build or find a house with

Storage

Workout room

Imaging area

Dorothea's office

Conference area

Bathroom

Charly's office

Stephanie/ Lee's area

The renovated basement that serves as TP Design's studio offers enough space for four workstations, a conference area, and even a workout room for employees to use in their free time.

a full basement that wasn't finished, so we could construct it in a design that could accommodate our studio," says Palmer.

Taylor-Palmer owns the house where TP Design is situated. Because Palmer and Taylor-Palmer formed a partnership where they share equally in the firm's profits and obligations, TP Design pays rent to Taylor-Palmer. Palmer points out that this expense is significantly less than what it would cost to rent comparable space in an office building. "Costwise, there's no major overhead, which has allowed us to buy more of the latest technology," says Palmer. TP Design is well-equipped, with six networked Mac stations and a PowerBook.

TP Design continues to grow with an impressive client list that, in addition to Coca-Cola, includes Disney's Wide

World of Sports, the TNT network and TBS Superstation. Their unique blend of design and illustration, which Palmer calls "design-a-stration," has been especially effective in targeting sports- and youth-related markets. "A mistake many

A decorative corner in TP's studio.

STUDIO EQUIPMENT

Computer	Apple PowerBook G3, Apple Power Mac G3, Apple Power Mac 8500 (two stations), UMAX SuperMac 500, Apple Power Mac G4 Server
Color Printers	Tektronix Phaser 780 and Phaser 480
Black-and-White Printer	Hewlett-Packard 4MP
Scanner	UMAX Powerlook II
Photocopier	Minolta
Other	Fujitsu Optical Drive, ClubMac CD Burner

Visitors and employees can enter TP Design through an interior stairway or use a separate entrance at the back of the house (right).

TP Design's conference area includes recessed book-shelves with reference materials and a wall where the firm can display its numerous awards. The bottles on the ledge are one-of-a-kind past self-promotion pieces.

TP Design was commissioned by the 1996 Atlanta Olympic Committee to design the Olympic souvenir poster (above) celebrating female athletes. Its style is typical of the firm's unique blend of computer-enhanced illustration and design that has brought them so much recognition.

people make is that they do the illustration, do the type and then try to bring it all together," says Palmer. "We tie it all together at the beginning so it's complete." To handle their expanding workload, the firm has taken on a full-time administrator as well as another full-time designer.

Palmer, who serves as TP Design's client rep, has never found himself in a situation where the firm's credibility has been questioned because of its home-based venue. "What we try to do is let them know that we're legitimate and see how we're set up. Our studio is structured in such a way that when you come into this environment it feels like an office," says Palmer, noting that the studio has its own entrance.

Palmer points out that the home-based office has allowed his partner Taylor-Palmer to work late without having to commute during the middle of the night. "Before we relocated here I was always really uncomfortable with that," he explains. "Now if she works long hours, I don't have to worry about her safety."

Among TP Design's recent projects is a series of products that commemorate baseball's Negro Leagues (right). In addition to designing player figurines and commemorative team plates and mugs, the firm also designed packaging for these products.

To generate business, TP Design sent out a self promotion piece (above): a custom imprinted wooden box with a sliding lid containing bound, printed samples of the firm's work.

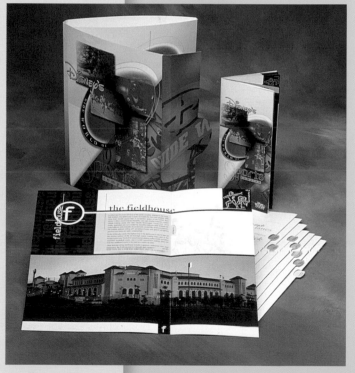

TP Design's work for Disney has included designing this media kit for Disney's Wide World of Sports.

7

BID ON JOBS AND GET PAID

❋ You've got a handle on the funds you'll need to run a business out of your home and what you should charge for your work. You've also got some potential clients lined up and the possibility of doing some projects. Here's how to bid on a project and get paid for your work. ——————→

Write a Proposal

Bidding on a job requires a written statement outlining what you'll do for the client and what you expect to be paid for your work. How detailed and extensive this statement is depends on the project. If your client wants a full-page ad for her business, your proposal will be simple and short. But if your client wants you to come up with a strategy for promoting her business, even though it may come down to only a full-page ad, your proposal will be more comprehensive.

Your proposal serves two purposes: competition and planning. Your client will evaluate your proposal and your competitors' and compare costs and concepts. If you win the bid, even if you had no competition, your proposal becomes your guideline for proceeding with the project.

Your proposal should include the following:

* **Affirmation**. Reiterate the project's communication goal or what your client wants you to do based on your conversations with him or her.

* **Analysis**. Show your understanding of the problem at hand by explaining what you think needs to be done to attain the project's goal.

* **Strategy**. Outline what you will do to fulfill the project's goal and the components that will comprise the project.

* **Costs**. Calculate your fees and other expenses involved.

* **Timetable.** Describe how long you anticipate it will take to complete the project and why.

* **Assurance**. Cite evidence of expertise in this area by listing jobs and other clients for whom you've done similar projects. Convince your client that you're the best candidate for the job.

If you're bidding on a simple job, this process can be streamlined to a single statement describing what you'll do, how much you'll charge and when you'll deliver. But if you're bidding on a fairly comprehensive project, you'll need to cover all of the above areas. Sometimes it may be more advantageous to not include your fee or timetable. Be sure you find out exactly what the client wants in a proposal before you begin writing yours.

If you can, present your proposal face-to-face and bring samples of similar projects you've done for other clients. That way, you can answer questions in person and point to specific examples of how you've effectively solved similar problems in the past.

If you need to overnight or e-mail your proposal, try to include the visual samples that you would have presented in person. Follow up the next day with a phone call to be sure your client received everything and to answer any questions. Even if everything was received with no problem and your client has no questions, this follow-up call is important for letting your client know how interested you are in doing the project and indicating how proactive you'll be if you get the job.

Client Contracts

When you and your client have agreed that you'll do the job, you'll need a written agreement that confirms the terms you've agreed upon. Both you and your client will sign this, and both of you will retain a copy for your files.

In some cases, your client may furnish a contract. Check it carefully, or have your lawyer look it over, to be sure the terms of the contract meet your approval. If your client merely shakes your hand and verbally agrees to have you do the work, follow up with your own written agreement. Never base a business transaction on a handshake.

When you're writing your contract, your proposal should serve as its basis. The terms and conditions you've already outlined in your proposal should be reiterated, and any changes you and your client have agreed upon should be incorporated. In addition, include the obligations your client will fulfill—text copy and/or images that will be furnished to you and when and in what form you will receive them.

Also include a description of who will take responsibility for the expenses involved in completing the job; for instance, specify who will pay for the printing and how it will be billed.

Explain what constitutes extra work beyond the initial fee you've negotiated. Revisions can be very time consuming, and you need to be compensated for any corrections, additions and other alterations in your original work. Be sure you describe what's covered in the original fee and how additional work will be billed.

Include your terms for payment. If payment is due upon completion of the job, state this. If you and your client have agreed that partial payment will be due upon commencement with the rest due upon completion, state this.

Finally, describe the copyright protection for both you and your client as well as any other individuals who will contribute original creative work to the project.

Be Sure Your Client Can Pay for the Job

Nobody wants to get stiffed or have to badger a client for money they're owed, but the sad reality of doing business is that some clients have difficulty paying for work they commission from others. You shouldn't need to worry about this with large corporations or former employers, but you should exercise caution when dealing with new or small businesses. Here are some steps you can take to ensure that you get paid for your work:

* **Check the client's credit rating and reputation.** If you have not already dealt with this client or have doubts about its ability to pay, and if you have access through another business to credit bureau information, check out the client's credit rating. Call your local Better Business Bureau to find out if any complaints have been filed against the business. It's also wise to call other creative professionals and vendors you know and ask about their experience with this client.

* **Get credit references.** If your client is a new business or is new to your community, ask for three credit references. Provide a form (with your logo on it) for them to list the names and phone numbers of people at businesses they've dealt with before and sign. (Use a generic form from an office supply store as a model.) Contact each of these references. If there's any question about your client's credit history or if any of the contact names and numbers they've given you seem bogus, forget about this client.

* **Get your money up front.** If you have had trouble collecting payment from this client before or have any doubt about whether this client can pay, specify terms that require your client to pay 30 percent at the start of the project, 30 percent at the halfway point and the balance upon delivery of the project. In addition to discussing these terms, be sure you put them in the contract that your client will sign.

It's not at all unusual for new businesses to have to abide by such terms, and most clients will understand your need to have assurances that you'll be paid. Credit isn't given until it's earned. Clients with a checkered payment past have to re-earn the trust of creditors. Exercise the same degree of caution that a bank or any other lending institution would when approached by someone wanting credit. If a client balks at your request for credit references, a down payment or a partial payment plan, you may not want to work with them—they may have something to hide.

Charging Sales Tax

It's important to understand, first and foremost, that you don't pay sales tax—you charge your clients sales tax on the products and services they purchase from you. You are responsible for collecting sales tax for the state in which you operate and sending this sales tax to the state at designated intervals. If you don't charge the sales tax that your state requires on every taxable sale, you're still obligated to pay this amount. If the state discovers that you should have collected sales tax but didn't, you'll be liable for this tax plus penalties. State policies for sales tax vary. To understand your obligations, contact your state's division of taxation to learn how to register your business and when to file sales tax returns and turn in the sales tax you collect. You'll probably have to pay a small fee to register.

It's often hard for designers and illustrators to determine when they need to charge sales tax. Technically, you aren't required to charge sales tax for a "service rendered for resale." You may think you're supplying a service rather than selling a product when you design a logo, but a logo falls under the category of a product, along with packaging or brochure design as well as many other design and illustration applications.

The guideline is whether or not the work you do is going to be part of some-thing larger that will have a sales tax attached to it when it's sold. That means if you produce an illustration or the design and layout for a magazine which is sold as a taxable commodity, you shouldn't charge your client sales tax on your work, because your client will collect sales tax from every consumer who purchases the magazine. As far as the state taxation bureau is concerned, this constitutes services rendered for resale. When you're providing services rendered for resale, you may need to obtain a tax exemption form from your client to justify waiving sales tax charges in your bill.

You generally aren't required to charge sales tax on products sold to a client in another state or to a nonprofit organization that is tax exempt. However, regulations vary from state to state, so check with your state taxation bureau for policies that apply to you.

If you charge a client sales tax on a job, you're exempt from paying sales tax on the items you purchase to complete that job; let the sales clerk know that these items are for resale. When you bill your client, make sure you charge for these items (remember your 15 to 20 percent markup) and tack on the sales tax for the total amount billed.

Establish Terms for Payment and Collect on Unpaid Bills

In addition to being careful about who you work for, you'll need to establish terms that both you and your client can live with. We've talked about collecting money up front from new businesses or other clients without an established credit history, but we haven't talked about what kinds of terms to offer to your other clients. The industry standard is to invoice the total amount upon delivery of the work with payment due within thirty days. Since most of your bills need to be paid within thirty days of receipt, this will contribute to a smooth cash flow.

The terms you establish with your clients will often vary depending on your clients' and your needs. Allow steady clients with a proven track record some leeway if they need it. On a regular basis I work for a particular client whose accounting department insists on paying bills forty to fifty days after the date of my invoice. Another client, a magazine publisher, issues payment when the magazine comes out, usually about sixty days after I've delivered the work. They've been publishing for over sixty years and my business relationship with them spans close to twenty years; I don't feel the need to dispute their policy.

However, in most cases, you'll want to receive payment within thirty days of delivery of the work. In addition to including this in your contract, be sure that your invoice forms state these terms: "net thirty days."

If you don't get paid within thirty days, call your client and ask why you haven't been paid. It's usually more effective to make a phone call as opposed to sending a written reminder with *overdue* stamped on it. When you call, treat the situation as their oversight and get an explanation. Find out when you can expect payment, and end the conversation on an upbeat note.

If you don't get paid within sixty days, make another call as to why you haven't been paid. Listen to your client's reasons and be prepared to offer an alternative payment plan if this seems like a reasonable solution to the problem. Work with your client to come up with a schedule of smaller payments.

If the account hasn't been settled in seventy-five days, you could sue in small-claims court or hire a collection agency; however, agencies will often keep half of what they collect. Figure out what it's worth to pursue your money. If the amount due is small, it may not be worth litigating; but if it's a large amount, you should contact your lawyer. A letter from an attorney is often all that's needed to get your money, but you may ultimately need to take the case to court.

Before you consider threatening or litigating, determine whether you're dealing with someone unable to pay or someone who's delaying payment because they're experiencing cash flow difficulties. A client that's going belly-up will pay off some creditors through bankruptcy court, but one that's obviously solvent requires persistence and a tactical strategy.

Deal With Slow-Paying Clients

Don't assume that clients who don't pay on time are insolvent deadbeats who need to be sued. They're probably just behind in addressing their financial obligations, experiencing temporary cash flow problems or pushing their creditors as far as they can in order to invest limited liquid funds in other income-generating ventures.

Figure out where your client is coming from and why they're delaying payment. Ask questions of your client and others in the community to try to ascertain what the problem is. You don't want to alienate your client; you want to understand their situation and arrive at a solution for getting paid. Through experience, I've learned that it's typical for clients with a history of paying late to start off paying on time or even early. After awhile, payments get later and later. Deal with clients like these differently than you would those who are normally dependable but in a temporary financial bind. Play psychologist; develop a strategy based on how often your client needs your services and whether or not you can withhold something in order to collect payment.

I worked with a magazine publisher for several years who paid within my thirty-day payment terms for the first year. After that, payments began to fall behind until they were more than sixty days behind schedule. My client had many committed advertisers and thousands of subscribers, so I knew the magazine would probably stay afloat. Because it was published every other month, I found myself holding each issue's contribution hostage until I had been paid for the previous issue's material. I let my client know that I wouldn't deliver my digital files to the printer until I had received payment for the prior issue's overdue invoice.

I arrived at this solution by talking with my publisher's vendors. I found out that no issue was ever published until all of the parties involved had been paid for their work on the previous issue. The magazine's service bureau, printer and all of the writers and photographers were caught up in a situation that allowed my publisher the luxury of paying for a past issue when payment on the current issue was due. I finally told my client I wanted payment for the prior issue and the issue currently due before I delivered.

Every situation is unique. Be aware of the influence you have on other designers or vendors your client relies upon. Know what your options are, and take advantage of the leverage that you have.

CASE STUDY | Contacts and Referrals Bring Business

L IKE MANY WOMEN WHO WORK AT HOME, RENEE KUCI DECIDED TO START HER HOME BUSINESS WHEN HER DUTIES AT HER FULL-TIME JOB BEGAN TO CONFLICT with her maternal instincts. "I had a two-year-old," she explains. "I didn't want to put him in day care, and I was having trouble finding help." So after seventeen years of working in ad agencies in the Greater Miami area, Kuci decided to quit her job as senior art director at Turkel Schwartz & Partners and start her own home studio.

Business has been going like gangbusters ever since Kuci established Woman on the Verge in 1997. Because Kuci had worked as an art director and designer for so many years, she was able to easily find freelance work through her many professional contacts. "When you know all of the printers down here, they

start referring business," she relates. Kuci has also picked up jobs through other freelancers. "I have a girlfriend who's a freelance media director," says Kuci. "She has clients who say, 'Do you know anyone who can do creative?' I've worked with her for over ten years, so we feel very comfortable recommending each other."

Because of her agency experience, Kuci originally thought she would be busy taking on overflow work from ad agencies. Instead, she's found most of her work has come from businesses that either can't afford to hire an ad agency or can't get their jobs turned around as quickly as they'd like through an agency. "I know from working at agencies that there's a lot of work going through there," says Kuci. "Clients often can't get a job done fast enough." Kuci says she also takes on jobs that fall outside of an agency's realm of experience or their contractual arrangement with a client. "I do

> *"I've been in this business so long down here, I know a lot of people."*
>
> RENEE KUCI

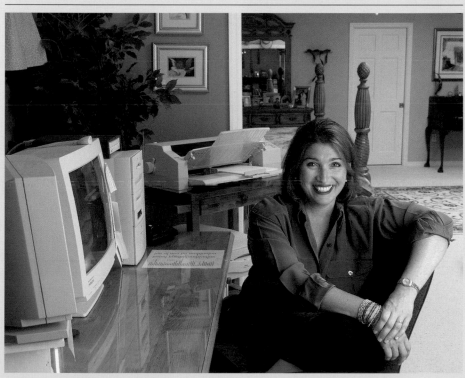

Renee Kuci

[Bid on Jobs and Get Paid]

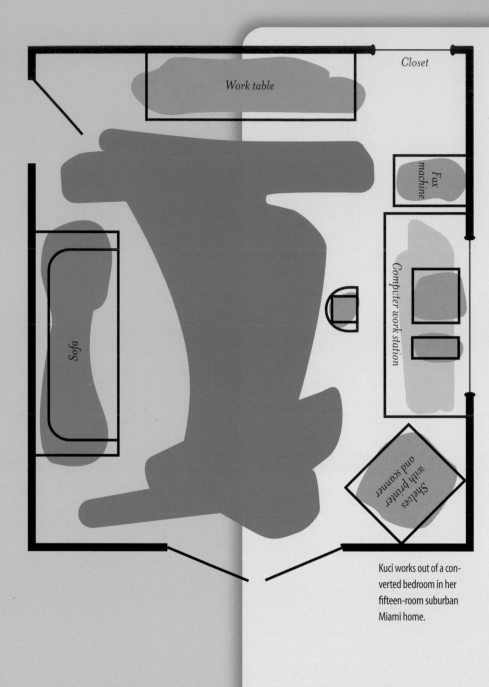

Closet

Work table

Fax machine

Computer work station

Sofa

Shelves with printer and scanner

Kuci works out of a converted bedroom in her fifteen-room suburban Miami home.

the projects that are so small that it's not worthwhile for the agency to do them," she relates. Many of these jobs are ads, direct mail pieces and posters.

With the low overhead of working out of her home, Kuci can price her work on a competitive level with ad agency fees and still enjoy a comfortable profit margin. "One of the biggest benefits for a business to work with a freelancer is that it obviously doesn't cost as much," she states.

Her work with local businesses has been lucrative and fulfilling, but Kuci has learned that she needs to be cautious about taking on new clients. Early on, she had to deal with a client who didn't pay her. "It was a first-time thing," she relates. "I shouldn't have trusted them, but I did." Kuci eventually got paid when her lawyer wrote a letter to the client. Now, she asks for a deposit up front from new clients.

Kuci likes the convenience of being able to structure her work hours around the time she spends with her son. "I enjoy my days taking my son to school, picking him up and going to T-ball," she relates. "I schedule meetings for when my son's in school. Oddly enough, I tend to do most of my work at night after everyone has gone to bed. I come into my office at about ten o'clock and that's when I'm most productive." It's a full day for Kuci, but she's getting everything that she wants out of life. Says Kuci, "I'm getting the best of both worlds." ✤

STUDIO EQUIPMENT

Computer	Apple Power Mac G3
Color Printer	Epson Stylus Color 1520
Black-and-White Printer	Apple Personal LaserWriter 320
Scanner	UMAX flatbed scanner

Kuci designed many elaborate mailers directed at cable media buyers when she served as senior art director at Turkel Schwartz & Partners. Because of this experience, she continues to design for Turner Broadcasting (right) and the Discovery Channel campaigns (below) directed at their South American as well as North American cable affiliates.

Kuci designed the letterhead
and business card set
(above) for
clickpharmacy.com.

For her former employer,
Kuci has designed poster
projects that the agency
sometimes can't get to as
quickly.

[Your Perfect Home-Based Studio]

✳ You'll need to pay tax on the income from your home-based business, but this is when working at home pays off: you get to write off a portion of your home expenses as business expenses. It's not complicated and will help you save a lot of money.

INCOME TAX

Paying Taxes on Corporate or Partnership Income

If your business is a partnership or a C corporation, your tax situation is very different than if it were a sole proprietorship or an S corporation. You won't deduct a portion of your home expenses; instead, your business will pay rent to you, the homeowner, and deduct it as a business expense.

As an employee of your corporation, you'll have income taxes withheld from your salary just as if you worked for someone else, and you'll include your wages as income on your personal income tax returns. You'll also pay taxes on your business income at both state and federal levels, and in some cases, on local levels depending on where you live.

If you're thinking of setting up your business as a partnership or C corporation, don't try to figure this out on your own. It's essential that you work with an accountant to set up a system for this and work regularly with this individual to keep abreast of tax law changes.

➤ If your business is a sole proprietorship, a partnership or a Subchapter S corporation, you are considered self-employed. Since you don't have an employer deducting taxes from your pay throughout the year, you are responsible for making payments on your estimated federal income tax for the year.

You'll make quarterly payments towards what you owe for the next year's income tax on June 15, September 15 and January 15. (These dates may vary by a day or two in any given calendar year.) The amount each time is one-quarter of what you paid in self-employment income tax for the prior year, with the balance due on April 15. Or you can make quarterly payments based on 90 percent of what you estimate you'll owe for that year.

If in your second year of business you base your payments on your first year's profits and you're making much more money than you did in your first year, you'll have a large balance due on April 15. This may be an overwhelming financial burden to assume at tax time.

Likewise, if your business took off from the moment you started, you should probably make quarterly payments even though you have no track record. Otherwise you may find yourself owing thousands of dollars come April 15.

When you file your federal return on April 15, you'll also need to pay self-employment tax to cover what you owe for Social Security and Medicare. When you're employed by another, it's your employer's responsibility to make these deductions from your paycheck and pay the employer portions, but as a self-employed individual, you're required to pay this tax on an annual basis. Your tax accountant can help you determine what tax bracket you fall into, but plan on setting aside 25 to 40 percent of your profits for taxes.

Determine Your Deductions

As a business owner, you qualify for a home office deduction if you've set aside an area of your home exclusively for business use. With a home office deduction, you can deduct a portion of your home expenses based on the percentage of your home that's used for your business. Determine the square footage of your studio area and calculate that as a percentage of the total square footage of your home. Don't be tempted to take 10 percent if you use one room in your ten-room home; the IRS bases these deductions on square footage. The area you deduct must be devoted exclusively to your business. Merely setting up a photocopier in the corner of your dining room doesn't qualify your dining room as business space.

Apply the business percentage of your home to the following expenses: rent payments or the interest portion of your mortgage; property taxes; homeowners' or apartment dwellers' insurance premiums; water, electricity and other utility bills; home maintenance and cleaning expenses; and home security system payments. A phone line used for both personal and business calls isn't deductible, but an additional line used exclusively for business is, as well as long-distance calls made exclusively for business. Home improvements that are needed for your business, such as a storm door to protect packages left by couriers, are deductible, as well as other home-related expenses directly affecting your business, such as painting your studio or fixing a leak in your studio.

The IRS lets you, like any other business, also deduct 100 percent of your operating expenses from your business income. This includes costs for furniture, equipment, supplies, postage, shipping, accountant's and lawyer's fees, tax preparation, trade books and magazine subscriptions, equipment maintenance, professional conferences and business-related travel including lodging. (Business meals are deducted at 50 percent of their cost.)

The IRS offers a lot of free information, including a booklet with specific information on setting up a home office. If you're confused about what qualifies as deductible expenses, call them at (800) 829-3676 to obtain a free copy. If you need further help, call the IRS at the twenty-four-hour, seven-day-a-week hot line: (800) 829-1040.

Tax Benefits for Employees Commissioned to Work From Home

If you are a salaried employee commissioned by your employer to do work from your home, you should be eligible for a home office deduction. To claim a home office deduction, you must use your studio space exclusively and regularly for your work. In addition, the business use of your home must be required and expected by your employer. To support this claim, get a statement in writing to this effect from your employer.

Organize Your Financial Records for the IRS

If you maintain a ledger book or disbursement journal, you already have your expenses sorted into categories. If you haven't, and you're relying on receipts and checks as a means of tracking expenses, sort them into the categories listed in "Keep Track of Income and Expenses" in chapter six, and give your tax accountant the annual total for each.

You'll need to document your business expenditures. This documentation includes:

✻ **Receipts for all travel and entertainment expenses.** If you take a trip, hang onto your receipts for airfare, lodging, cab fare, parking, car rental and meals. For meals make sure you note the

Manufacturers of planners and personal organizers also sell travel log inserts that can be used for recording business mileage.

MILEAGE
BUSINESS LOG

DATE FROM - TO: 2·15 — 2·18
COMPANY: DOE GRAPHICS

DATE	DESTINATION		BEGIN ODOMETER
	DESTINATION	ACCT. CODE	END / BEGIN
TIME DATE	PURPOSE		
	EXPENSES FUEL / TOLLS / PARKING		TOTAL
2·15	REMO'S / LUNCH WITH NEW CLIENT		35,024 / 35,035 / 11 MI
2-16	EDGE GRAPHICS / CHECKING BLUELINES		35,072 / 35,085 / 13 MI
2-16	PRECISION / PICKING UP NEGATIVES		35,090 / 35,103 / 13 MI
2-17	TOTES / CLIENT MEETING		35,105 / 35,121 / 16 MI
2-18	COMMERCIAL SUPPLY / PURCHASING EQUIPMENT		35,140 / 35,154 / 14 MI

[Your Perfect Home-Based Studio]

amount of the tip on the receipt. Get receipts when you treat a client or associate to lunch, dinner or cocktails.

❋ **Receipts for any purchases that are petty cash expenditures.**

❋ **A travel log.** Keep a notebook in your car where you record your mileage, along with the date and where you traveled for every business-related trip. Your accountant will base a travel deduction on the total business mileage you've logged. If you're ever audited, the travel log substantiates your business travel deductions.

If you use the services of other creative professionals, such as copywriters, illustrators and photographers, in the production of your work, separate these fees from those of other professionals. In order to deduct their services as a business expense, you'll need to get their Social Security number or EIN and send them a Form 1099 declaring how much you paid them in a tax year by January 31 of the following year.

Also separate any expenses for new equipment and office furniture—large

purchases that your accountant can depreciate. Depreciation allows you to deduct a portion of the cost in each of several years, rather than deducting the total amount in the purchase year. Expenditures for home improvements, even converting an attic into a studio, are also deducted via depreciation. The IRS makes a distinction between capital improvements, which get depreciated, and ordinary repairs to your studio, which are 100 percent deductible in the year of the expenditure.

Of course, you'll also need to total your earnings. This would be your gross receipts—the total of all paid invoices, royalties or other fees you collect during the year.

Finally, the IRS has taken steps to discourage hobbyists from writing off studio space in their home. You can only take a home office deduction if your deductions are less than the gross income you derive from the use of your home office. Likewise, you must show a profit after three years of doing business in order to continue taking a home office deduction.

Growing Business Spawns an Addition

"I've experienced both environments, and I definitely prefer working at home."

BRENDA WALTON

βRENDA WALTON STARTED HER BUSINESS IN 1977, SHORTLY AFTER RECEIVING A MASTER'S DEGREE IN STUDIO ART FROM CALIFORNIA STATE UNIVERSITY, SACRAMENTO.

"I was teaching at a local community college and working on small-scale lettering jobs part-time," says Walton. Soon the calligraphy commissions began to grow significantly, and at the suggestion of her husband, Doug Peckham, she stopped teaching and concentrated on calligraphy as a full-time business.

Her efforts have paid off. During the past twenty-three years, Walton's business has grown to encompass product design and illustration, as well as calligraphy. Her work has been featured nationally on stationery collections, gift products, packaging and advertising applications. She has also applied her skills to home decor, developing designs for wall coverings, interior accessories and dessertware. The popularity of her imagery has extended into a line of rubber stamps, bank checks, fine art prints, and even font design for International Typeface Corporation.

Walton knows what it's like running her business from a traditional office, too. Although she started her design career at home, in 1987 she decided to share office space with an established graphic design firm. "I felt like it would really improve my business skills," says Walton. "I'm so glad I had the opportunity to work with seasoned professionals. It was a great education for me, one which could never have been duplicated in a classroom."

After five years of renting and sharing office space and establishing her business on a national scale, Walton decided to remodel her family's home to add a home studio. "The overhead was becoming quite a burden, and I found that my hours were getting more and more

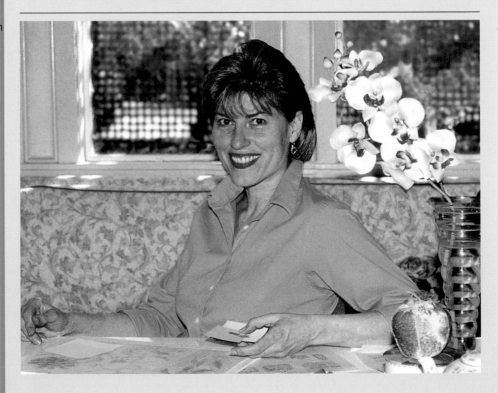

Brenda Walton

extended into the evening and that being with my family was continually being reduced," she says. "It just made sense for me to work at home again."

To accommodate her growing business, Walton and her husband decided to invest in a 700-square-foot (65.1m²) addition to the rear of their Sacramento home. She talks with enthusiasm when describing the space. "The studio has three large windows looking out onto the covered patio and garden," says Walton. Because her husband is an avid gardener, the view provides an inspiring perspective on the seasonal changes of the plants, animals and insects of northern California.

Besides being an idyllic setting in which Walton can work, the studio addition was a wise personal financial investment for the artist and her husband. A portion of the new studio's design and construction cost of slightly more than $100,000 can be written off as a business expense. They estimate that the new studio has added 25 percent to the value of their home.

In addition to a fax machine, phone and other office equipment, Walton has equipped her studio with four Macintosh computers, a combination color printer/

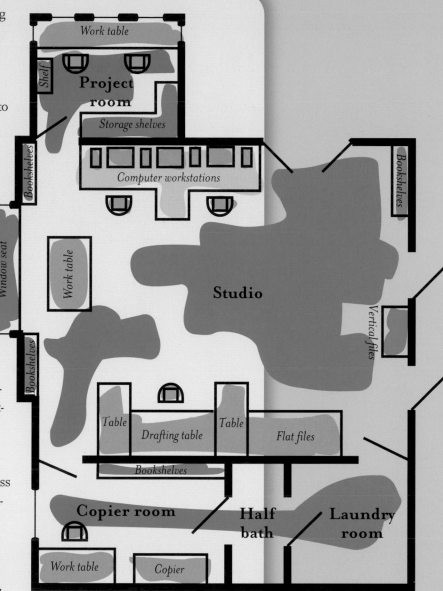

A new addition to her home provided Walton with the extra space she needed for her studio as well as other value-added rooms, such as a laundry area and a half bath.

STUDIO EQUIPMENT

Computers	Apple Power Mac G4, Apple Power Mac 8600, Apple Power Mac 7200, Apple Power Mac 7100
Color Printer/Scanner Photocopier	Epson Stylus Scan 2500
Black-and-White Printer	Hewlett-Packard LaserJet 4000N
Photocopier	Minolta EP (purchased used)

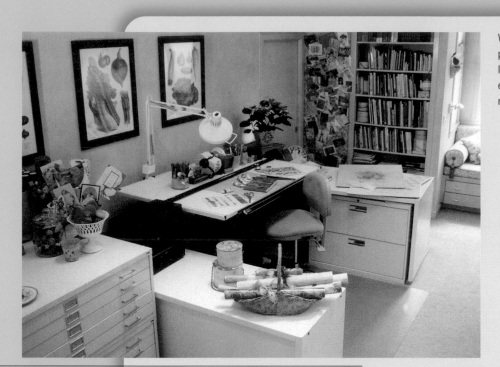

Walton's studio addition provides optimum lighting. Its tall, pitched ceiling is equipped with skylights and recessed halogen lighting.

Walton's work appears on many packaging applications, including some Bath & Body Works products. She also developed the design and illustration for Twin Scents's line of Highland Rose bath products (right).

management and her Web site (www.brendawalton.com). Walton is fortunate to have technical expertise on hand; her son is a computer science major at California Polytechnic University, San Luis Obispo.

"Despite the creative stimulation and professional relationships I enjoyed by sharing office space, I definitely prefer working at home," says Walton. "I work well in a quiet environment where I can control the noise level and turn off the phone when necessary. My productivity has increased measurably because my at-home surroundings have improved my ability to focus." Her business move back home has also given Walton the flexibility to work whenever she wants. "For me, creativity doesn't operate on an eight-to-five schedule. I consider working at home to be the ultimate luxury. My working hours have increased, but fortunately I love what I do. I could paint twenty-four hours a day." ✵

scanner/color copier, DSL (digital subscriber line) phone and Internet service, a black-and-white printer and a black-and-white photocopier. Although she normally works in traditional media and uses two Macs for graphic design, record keeping and Internet access, her studio network includes two additional computers for e-mail, database storage and

Schurman Fine Papers is one of Walton's largest clients. Her work for Schurman includes greeting cards and the Romantique stationery collections (right and below left).

Walton's calligraphy is often used for brand and other identity applications, such as her design for Portofino ice cream's logotype.

9

PROTECT YOURSELF AND YOUR BUSINESS

❋ When you become self-employed, you are your business. This means that you not only need health insurance, but you also need to cover expenses when you can't work. Additionally, you need to protect your business assets and make sure you have liability protection in case somebody is injured on your property. ⟶

Find the Best Deal on Health Insurance

When you were a full-time employee, your employer probably had a group policy that took care of your health insurance. If you're fortunate enough to have coverage through your spouse's employer, you don't need to worry about this. However, if you're single or can't get coverage through your spouse, you'll need to secure your own health insurance.

Group rates usually offer the best deals; however, home-based businesspeople don't generally qualify for the group rates typically offered to other businesses. If you've decided to incorporate and you employ other people, you might be able to get a policy at a group rate. Husband-and-wife teams operating out of their homes will often qualify for a group insurance policy if their business is incorporated.

Unfortunately, it's not likely that you'll find a deal on group rates through a professional design or illustration organization. Some speculate that this is because insurance companies see those involved in artistic fields as being a high-risk group. Professional organizations not affiliated with the graphic arts, even your local chamber of commerce, are more likely to offer insurance at better group rates. Locally based, self-insured funds are also available in some areas for printers and others affiliated with the printing and prepress segment of the graphic arts industry. An independent insurance agent can usually give you information on group possibilities in your area, if they exist.

If you're in good health, you may find that an independent policy will be less expensive and more suitable to your needs than any group benefits. If you just want coverage for hospitalization in an extreme emergency, you can save money by opting for low premium payments on a policy with a high deductible. Remember when considering any type of coverage that the higher the deductible, the less the monthly premium costs.

On the other hand, if you have a family to take care of, an HMO (health maintenance organization) or PPO (preferred provider organization) will cover you and your loved ones for medical emergencies as well as for most checkups and other medical needs. Again, an independent insurance agent can provide information on what your coverage and cost options are.

Evaluate Health Care Plans

If you decide to get an independent policy for yourself and your family, shop around to find a plan that suits your needs and pocketbook. No general rules apply; what suits you best will likely depend on how much you typically spend on health care, any preexisting conditions and how much you want to spend.

Before you begin, determine what you currently pay annually for health care, including prescription drugs and dental needs. Determine what your health care needs will be for the coming year: the number of well visits you and your family will need, sick visits, allergy shots or other ongoing care, as well as whether you anticipate the need for maternity benefits. Also decide on how important it is for you and your family to be treated by the physician of your choice.

Here are some things to consider for each insurance plan you're reviewing:

* **Annual premiums and deductible**

* **How claims are paid, based on usual and customary charges or on total charge**

* **Amounts of co-payments and when they are required**

* **Whether your physicians are participating physicians**

* **How much you will have to pay if you use an out-of-network physician**

* **Maximum out-of-pocket costs**

* **Outpatient costs and whether a maximum applies**

* **Whether preexisting conditions will affect premiums**

* **Out-of-pocket costs for prescriptions**

* **Whether a rider is available for prescription drugs**

* **Participating dentists and annual premiums for dental coverage**

* **Frequency of and reasons for rate increases**

* **Guaranteed renewability if you make your premium payments on time**

If you're covering more than just yourself, it might be worthwhile to consider separate plans for each member of your family, particularly if the age or preexisting condition of one member of your family will cause a higher premium for coverage.

After comparing companies and weighing the benefits you receive from each against what you're paying now and your anticipated medical expenses, you should have some idea of what kind of coverage works best for you.

Disability Insurance

Health insurance only takes care of your medical bills in the event of an accident or illness. How do you cover other bills while you're laid up and unable to work? That's where disability insurance comes in. Some of the factors you should look into when shopping for disability insurance follow:

✳ **How "disabled" you must be to receive benefits.** Some plans define "disabled" as "totally disabled," meaning unfit for any kind of work. An illustrator unable to work because of a broken hand wouldn't benefit from this type of coverage. Look for a definition of "dis-

abled" as "unable to engage in any gainful occupation for which the insured is suited by education, training or experience."

✳ **How long you must wait for payments.** Insurance companies have widely varying waiting periods, ranging from seven days to six months.

✳ **Whether the policy is "noncancelable" and "guaranteed renewable."** Such a policy can't be terminated after you become disabled or make a claim, so look for this type of policy. ⟶

Find a Good Agent

Like your lawyer, accountant and computer technician, your insurance agent also plays an important role in your success by supplying knowledge and services that go beyond your realm of expertise. Save yourself the grief of considering a different agent for each of your insurance needs; most agents will offer you a discount if you purchase all of your insurance needs through them. In the long run, dealing with the same agent will save you time as well as money.

Like considering the services of any professional, get referrals from other creative professionals when it comes to hiring an insurance agent. Friends, relatives and neighbors are also good sources for referrals, but be leery of giving your business to a friend of a friend or to a relative. Don't buy your auto insurance through your down-and-out cousin just to help him. Establish a long-term relationship with someone who's easily accessible, objective, knowledgeable about what you need and, most important, willing to be your advocate when you need to file a claim.

Property Insurance

Now that your business is part of your home, you should modify your current homeowners' or apartment dwellers' policy to get additional coverage for your business equipment and records, as well as protection against liability in case a business visitor, employee or courier is injured on your premises. You'll definitely need more insurance if you plan to lease equipment.

Before considering the additional insurance you may need, check your policy to determine your current coverage. Your current policy may cover all of your liability needs. Other policies limit liability coverage to nonbusiness visitors. Some homeowners' and apartment dwellers' policies may explicitly exclude coverage for any business use of your home. In this case, you would need to get a business owners' policy added onto your homeowners' or apartment dwellers' insurance.

Other policies will cover computers and up to five hundred dollars in business property in the event of damage or theft. However, this probably won't be enough when you consider the value of all of your equipment plus your records.

Many policies will allow you to add a business endorsement or rider. If your policy allows this, it's an easy way to get the additional property coverage you need, take care of your liability needs, cover lost income due to business interruption and cover business equipment damaged in or stolen from your car.

Because home businesses are regarded by the insurance industry as relatively low risk, the additional coverage shouldn't cost you much more than your current policy. You should be able to add a business endorsement or rider to cover liability and property for an additional one hundred to two hundred dollars per year. However, a business owners' policy may cost you more, typically three hundred to four hundred dollars per year.

Other considerations that you should keep in mind when determining what you need to protect your home-based business are:

* **Auto insurance.** If you use your car for business more than 25 percent of the time, you may want to amend your auto insurance with a "business use" endorsement. If you hire somebody who will drive your car, you should amend your policy by adding the employee to your list of insured drivers.

* **All-risk insurance.** If your current policy states "basic," "standard" or "broad" coverage, it will protect against natural peril, but it won't cover theft. Switch to an "all-risk" policy to include theft.

* **Replacement cost.** If your policy states that items will be replaced at "actual cash value," you won't be reimbursed for the true value of the item. Switching to a policy that replaces your studio property at "replacement cost" means the property will be replaced at its current value.

10

DEAL WITH DAY-TO-DAY CHORES

❊ You're constantly busy with projects, and you understand the basics of running a business. To keep things humming along at a brisk pace and avoid having something fall through the cracks, you'll need systems for staying on top of jobs. ⟶

→ Whether you're compulsively neat or habitually sloppy, organize things so you can find projects, phone numbers and records when you need to. Everybody has a way of keeping tabs on their responsibilities, and your method of organization will be unique to the way you work. Nevertheless, here are some tools for a basic organizational system that works for most creative professionals.

* **Job jackets.** When you start a project, it's a good idea to create a job jacket. The job jacket will hold everything you need for the project—slides, photos, visual resources, notes from client meetings, correspondence, contact information, disks—as well as any information pertinent to the billing of the job. A large envelope will probably work better than a small manila file jacket because it can hold many types of job materials. Keep job jackets for current projects in a place where they're easily accessible. When the project is done, store its job jacket in a flat file alphabetically by project. That way, you can easily find and retrieve information and resources after the job is completed.

* **Calendars and day planners.** Use a calendar or day planner, or both, to keep track of appointments and deadlines. A day planner that you can take with you to client appointments allows you to refer to your schedule as you line up future meetings. When you return to your studio, transfer these appointments to a wall or desk calendar. A desk calendar gives you plenty of room to write in a day's activities, while a wall calendar allows you to see an entire month at a glance. If you use a wall calendar, purchase one that has plenty of room to write on each date.

* **Paper files.** You'll need, in addition to job jackets, a filing system to maintain contracts, purchase orders, invoices and other paperwork. The simplest way to do this is to use a vertical file cabinet and labeled hanging file folders.

* **Bins.** Develop a system for dealing with incoming mail and paperwork that you may not have time to get to right away. Prioritize your mail with a basket or bin for urgent matters and another one for correspondence that you can get to later. Place another bin on your file cabinet for records that need to be filed. You may want to use other bins in your studio for administrative tasks that you can't get to right away.

* **Address file.** An address or business card file is a great way to keep and find phone numbers and addresses; organize this information alphabetically. You may want two: one dedicated to vendors and professional service providers and the other to clients.

Keep Track of Jobs

As your business grows, you'll need to stay on top of keeping jobs on schedule. You should also keep track of how much time it takes to complete the tasks involved in each of the jobs you do. Here are some things you'll need to do to track the status of your in-process projects:

* **Create a production schedule.** When you get a job, before you do anything else, come up with a production schedule. Make a list of the tasks that go into the job and set a deadline for each of them. Include deadlines for the portions of the project that you'll do as well as things that will be done by illustrators, photographers, copywriters and production vendors. Plug these into your calendar or day planner and put a copy of the production schedule into the project's job jacket.

* **Prepare daily and weekly for work.** Your entries in your calendar or day planner serve as the framework for your weekly and daily activities. As you begin your week, review what needs to be accomplished by the end of that week. Each day look at the next day's entry so you'll be prepared for what you need to do.

* **Track your time.** In or on the job jacket you set up for each project, keep a sheet where you track your time for that project. This is essential if you're billing by the hour, but even if you've agreed upon a set fee, you should track your time so that you can determine whether you set a fair price for the work involved. This will help you make necessary adjustments in the future.

Set Conservative Schedules

 When you run your own business, you're responsible for delivering the job on time, despite any setbacks that are out of your control. To stay on schedule, have vendors complete tasks well ahead of your project's actual deadline. Why? Because Murphy's Law is usually right, and if something does go wrong, you're still responsible for completing the job on time. To protect yourself from things that may go wrong and delay production, pad your schedule accordingly.

Here's a case in point. Let's say you need to deliver a printed brochure to a client by a certain date. Your printer needs a week to print it, you need a week to design it and your photographer needs a week to come up with location photos for it. Sounds like it will take three weeks, right? Probably not. If your printer has a problem getting the paper you've specified, that can add extra days to the project. What if a press breaks down? That can add to the time frame as well. What if your photographer schedules a date for the photo shoot, but when he calls that day to confirm it, he finds out the CEO was called out of town on an emergency? After all this, your client makes several revisions to the comp. You take an extra day to incorporate them and get the client's final approval.

Realistically speaking, the project should be scheduled for a six-week time frame. Give your printer and your photographer two weeks each, allow yourself a week to design it, and plan another week for your client to review it and make revisions. Find out from everyone involved how much time they need and give them deadlines based on their input, but don't expect everyone to meet these deadlines.

Deal With Client Approval and Revisions

Clients will always want to make revisions at the last minute. It doesn't matter how well they proofed the copy or how many people were involved in the process. Something always needs to be changed.

Here are some ways you can discourage lengthy revisions and protect yourself against changes that will harm rather than improve the piece.

When you draw up the contract for the project, stipulate what kinds or how many revisions are included in the price and what the cost for revisions beyond this will be.

If you feel your client might balk at paying for revisions not included in your price, have them fill out a "client

change request form" where the extra charges are stipulated. This is also a good way of citing the perpetrator, if you're dealing with someone who's making creative decisions that diminish the effectiveness of the piece. This often occurs when a client you've worked with passes the project to a subordinate.

Let your client know how much time making their revisions will take, and whether this will delay the printing of the piece. This is often enough to discourage many clients from making excessive changes.

Finally, always have your client sign off on final art and initial proofs.

Prioritize

As an employee, you probably weren't bothered with administrative tasks such as filing, billing jobs and shipping packages or marketing tasks like cultivating new business. Now that you have your own business, you'll wear many hats. Juggling the tasks for maintaining a business requires an ability to make wise judgment calls on what needs to be done now versus what can be done later.

Here are some strategies to help you run your business smoothly:

* **Meeting deadlines is your top priority.** No matter what it takes, deliver your work when your clients expect it. There are a lot of talented people out there, and you may feel like you aren't offering anything that's terribly unique. The fact is that there are a lot of talented flakes out there. People who consistently get work done on time have a considerable competitive edge. Being dependable might not make you an overnight sensation, but it's likely to bring you long-term success.

* **Lengthy projects can be put aside.** The best type of work situation to have is a steady flow of short-term projects, which have to be turned around quickly, counterbalanced by lengthy long-term projects that can occupy the gaps between the short-term projects. That way you're always busy. The trick is to table the long-term assignments when you need to. Don't get so consumed in a project that you can't put it aside for a more lucrative job with a tight deadline.

* **Keep the broad picture in mind.** Remember the need to chip away at long-term projects so you're not overwhelmed with more work than you can handle at the last minute. Set aside time on a daily or weekly basis to complete these projects. If necessary, add an extra hour to every business day to get the job done.

* **Maintain cash flow.** It's natural to assume that administrative tasks can be put off. That's true, for the most part. The exception is invoicing your jobs. It only takes a few minutes, and it's essential to maintaining the income you need to keep going. Invoice your jobs as soon as they're completed.

* **Keep looking for future business opportunities.** Don't overlook the need for self-promotion. Sometimes you'll be so busy, the last thing in the world you'll want to think about is taking on another project. But if you don't keep an eye on where your future business is coming from, you may find yourself with fewer clients and less work in a year's time.

* **Don't pass up big opportunities.** A project for a major client is due tomorrow; you've prearranged a one o'clock meeting time to deliver it. The day before, an out-of-town prospect calls with your dream project. She's in town for just one day, and the only time she can meet with you is lunchtime the next day. I'd try to reschedule my delivery meeting. You know the old adage: Opportunity only knocks once.

CASE STUDY | **Work Defines a California Couple's Lifestyle**

> *"Our home is a creative environment. It's like a studio."*
>
> CHRIS GARLAND

F OR CHRIS AND PATTI GARLAND— OWNERS OF XENO DESIGN—WORK, LEISURE AND DESIGN ARE ALL PART OF AN INTEGRATED LIFESTYLE THAT HAS TURNED their suburban Los Angeles home into an area where the couple can engage in creative fulfillment around the clock. "For the most part, work is play," says Chris Garland. "We get up, we keep going right on through the day, and we always continue the process into the evening."

Xeno Design is a successful design business which has been serving clients in the Los Angeles area since 1989. The company was first established in 1981 in Chicago, where the Garlands initially set up shop in their home to produce *City*, a Chicago lifestyle magazine. "Xeno Design was the art direction service for the magazine," explains Chris.

Xeno Design took on other clients beyond City magazine and eventually outgrew the couple's home-based office. When the economy went sour in the late 1980s and Xeno Design needed to downsize, the Garlands decided to pull up stakes and relocate their home and business to greater Los Angeles. "We enjoyed Chicago," says Chris, "but we had always looked beyond, particularly to the West Coast because it's warmer, sunnier and there's a lot of energy."

Patti and Chris Garland

The Garlands make the most of their sunny, California climate, using their poolside patio both as a meeting room and as an area to relax and dine.

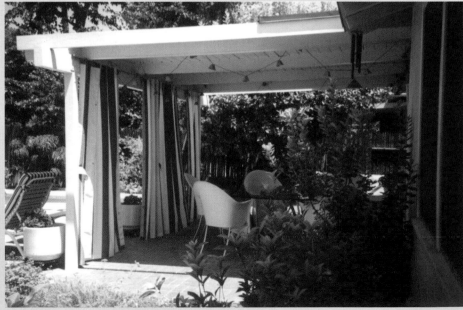

[Your Perfect Home-Based Studio]

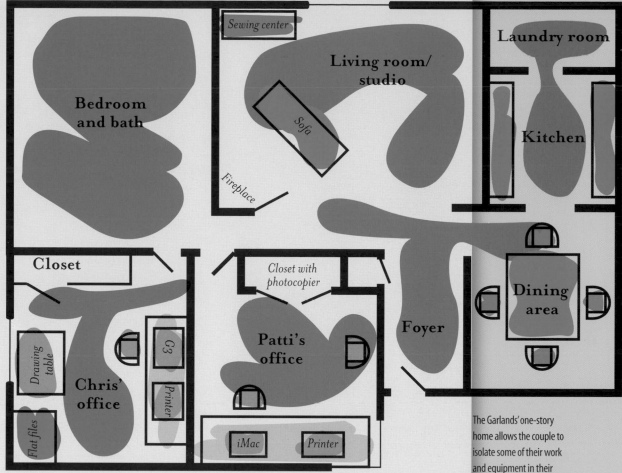

Sewing center

Living room/ studio

Sofa

Bedroom and bath

Fireplace

Laundry room

Kitchen

Closet

Closet with photocopier

Drawing table

G3

Printer

Chris' office

Patti's office

Foyer

Dining area

Flat files

iMac

Printer

The Garlands' one-story home allows the couple to isolate some of their work and equipment in their offices, while other rooms serve as combined work and living areas.

When the couple moved to Los Angeles they resumed working out of their home—initially a rented house; later, a six-room house which they purchased in 1991 in Van Nuys. The couple has dedicated entirely to the business two rooms, where computers, office equipment and file cabinets are housed. "We also have a patio that extends out from the living room into the backyard," says Chris. "We have what used to be our conference room table out there that can be used for business meetings or for a nice dining table." Beyond the patio is the couple's backyard and pool. "That's the beauty of southern California," says Patti. "You can open things up, and everything flows from inside to outside. It really helps extend our space."

The couple's living room functions as combined work and living space. Patti, who recently got involved in fashion design, uses the living room to house her sewing equipment and mannequin. Equipment and furnishings in the home often migrate, depending on whether the Garlands are working or entertaining. "We have a lot of things on wheels," says Patti. "Every time somebody comes over they say, 'It looks different.'"

The Garlands' foray into fashion design has culminated in the introduc-

"It's a collection of creative bits and pieces," says Chris regarding the eye candy he's tacked above his desk for inspiration. The collection includes some of his own work as well as that of other designers and illustrators.

tion of a line of organic clothing called FuzziLogic, sold online at www.fuzzilogic.com. (Chris designs FuzziLogic's Web and print promotions.) Because Xeno Design was initially established as a corporation, it's been easy for the couple to restructure Xeno Design as their business ventures have changed. On paper, FuzziLogic is the brand name for a product Xeno Design offers.

The Garlands' free-flowing schedule is just one of the many perks they enjoy as a result of working at home. The couple eats gourmet meals at lunchtime that are far more healthful and satisfying than the fast-food fare that most office workers are stuck with during their lunch hour. Patti's specialty is Maharishi's Ayurvedic vegetarian cuisine, which combines spices and fresh vegetables in warm, aromatic dishes. "The food we eat affects how we think," says Patti. "I think it's one of the biggest pluses of working at home." ⌘

STUDIO EQUIPMENT

Computers	Apple Power Mac G3, Apple iMac, 3Com Palm Pilot
Color Printers	Tektronix Phaser 140, Epson Ink Jet 740i
Black-and-White Printers	two Hewlett-Packard LaserJet 4MLs
Scanner	UMAX Vista S8 with transparency adaptor
Photocopier	Xerox 5305
Other	Canon EOS Elan, Sony Mavica digital cameras

[Your Perfect Home-Based Studio]

Xeno Design's far-reaching creative expertise includes advertising and packaging design, logo and identity development and Web site design.

Integrated Care Communities LLC

Can a day care center help your child to bloom?

This one can.

Integrated Care Communities
Jan Peterson
Child Day Care Center

on the grounds of

Riverside County Regional Medical Center

Moreno Valley, California

Integrated Care Communities
Caring for the Circle of Life™

Digital Palace

FuzziLogic natural fiber knitwear with a twist CONTACT US

Patti & Priscilla

Dear Friends,

Welcome to FuzziLogic.

My latest project is a line of beautiful knitwear for women using natural organic cotton, and our first item is a knitted shawl. I hope you like it.

Thank you for visiting and come by often. I'll always try to have something new to share with you.

Best regards, Patti
Join our mailing list. Drop us a note and you'll receive promotions via Internet and regular mail.

What is FuzziLogic?

• Products that neatly match up to current consumer needs.

• Each product meticulously designed to fit the requirements of a modern environment.

• Buy better; buy less.

©2000 fuzzilogic.com and Xeno Design 6901 Mammoth Ave. Van Nuys, California 91405 U.S.A. (818) 782-4197 fax (818) 787-5668

All rights Reserved

Xeno Design [click here] a little red wagon
the best of L.a.

Chris designed FuzziLogic's Web site.

11

NOW AND IN THE FUTURE

When your home-based business starts to take off, take steps to solidify your client base, and make plans that will ensure your long-term success. Maintain good working relationships, and continue to promote your business as an established entity. Think about ways to protect your income by taking advantage of tax-sheltered investment plans available exclusively to the self-employed.

Cultivate Long-Term Client Relationships

Ask yourself how long it took you to land the clients you've been working with. You had to contact them and engage their interest. Then you had to show your portfolio and follow up with a thank-you note and perhaps a phone call. When they first called with a project idea, you had to create a proposal, meet with them and prove to them how sincere you were about serving them well.

But once you prove yourself with that first job, it gets much easier, right? It gets easier still with successive jobs. The bottom line is that clients want someone they can depend on. They dislike the interviewing process as much as you do. If you give them what they want when they need it, they'll continue to want you.

There's nothing better or easier than getting repeat business from long-standing clients. They've proved they can pay. You know what to expect and how to accommodate their preferences and whims. It's a low-risk situation.

Consider the alternative. Whenever you spend time seeking out and promoting yourself to new clients, that's time that could have been spent on money-making tasks. So if you've won over a client, treat them like gold. Let them know how much you appreciate working with them—tell them; after your first job, send a note thanking them for the opportunity to work for them; send a holiday card (at the very least) or a gift to thank them for their business.

Cultivate Long-Term Vendor Relationships

Get the Best Deal From Your Vendors

Over time, you'll often find that the first time you work with a vendor, they will hook you into doing business with them by offering some services for free or low-balling a quote on a job. When you've worked with the same vendor for awhile, prices start to creep up to a more realistic level. Nobody's trying to rip you off. This is the way business has been done in the graphic arts industry for years.

Nevertheless, it's wise to protect yourself and your clients by having more than one vendor bid on a project, even if you want to give the job to a preferred vendor that you've worked with before and trust. If your preferred vendor is in the ballpark but isn't bidding the lowest price, mention that you want to work with them, but you have a lower bid from another company. If you've done a lot of business with this vendor and they want to continue to do business with you, they'll probably match or come close to the lowest bid if they can.

Treat your vendors with the same respect as you show your clients. If you put the people responsible for producing your jobs on the defensive, they're less likely to be cooperative; and if they don't cooperate, you're not going to get the job done when you need to.

Think of what it's like to do business with a spoiled, unreasonable client. If you don't want to deal with temperamental, insensitive clients, why would your vendors? Don't be a bad client; treat your vendors with the same consideration you would show any other professional colleague.

It's also a good idea to work with the same vendors. Using the vendor who's quoted the best price on a job can be beneficial, but skipping around from one vendor to the next—playing competitors against each other—is probably not to your advantage. Here are some benefits of repeatedly working with the same vendors:

* **Consistent and reliable results.** Working with a vendor for the first time often requires ironing out some kinks in the production—like calibrating your computer monitor so you're in sync with your service bureau or printer. If you work with the same vendors, you'll get the results you expect without having to tweak or reengineer your work or equipment every time you send out a job.

* **Special favors.** Doing business with the same vendor over a period of time pays off when you're in a bind. If you need to have a job turned around in half the time it would normally take, you're more likely to get this special consideration if you've been a steady client and source of income for your vendor.

* **Client referrals.** When you've dealt with a vendor for awhile and they appreciate your capabilities and how easy you are to work with, they're likely to refer you to their other clients.

Long-Term Promotional Efforts

After a year of doing business, you should do a self-promotion mailing. Your self-promotion piece can be a brochure or some other means of showing some of the work you've done for clients in the past year, or it can be an entirely different piece that reinforces how creative and clever you are. Whatever you send, be sure it represents your best work and is memorable. Your self-promotion efforts remind past clients that you're still in business, doing well enough to afford a promotional mailing and interested in working with them on future projects. Most of all, it serves as a reminder of your creative capabilities.

In addition to sending your self-promotion piece to former and existing clients, send it to prospective clients you'd like to work with. Include a personal letter stating what you have to offer and why you want to work with them.

Don't forget your clients over the holidays. In addition to thanking those with whom you've done business, your holiday card should be an original design that serves, again, as a reminder of your capabilities. Many designers and illustrators develop two lists for the holidays: an A-list—regular clients, who receive a gift (a custom-labeled bottle of wine, for instance)—and a B-list —occasional clients and prospective clients, who receive a greeting card. (Remember to include your vendors and other professionals on your holiday B-list.)

To facilitate regular mailings, invest in software that will let you create a database. Database programs are specifically designed for organizing and formatting names and addresses so they can be printed on address labels.

➤ When you're working in an office environment with other professionals, you're constantly dealing with people. They call you, stop at your desk and continually demand your attention—so much so that you're often distracted from doing the work that you need and want to do.

When you set up shop in your home, you rid yourself of these distractions and annoyances. But nobody can prepare you for how isolating it can be to work alone from home. Losing that connection with other individuals can leave you feeling uninspired, unmotivated and, yes, just downright lonely.

Keep in mind that—even though you work at home—you're still entitled to coffee breaks and lunch breaks that allow you to network and gossip with your colleagues. In fact, when you're on your own, you have more control over when and with whom you take your breaks. Grab a cup of coffee and call a colleague you enjoy chatting with. Or send an e-mail to someone you'd like to hear from. Make plans to meet with a colleague or client at least once a week for lunch, just to get out and about and keep in touch. If you find youself looking forward to the mailman's arrival, take that as a signal that you need to get out. Run an errand, or meet someone for coffee or lunch.

It's important to network with vendors, potential clients, colleagues and others you currently do business with or would like to do business with. Networking with other professionals is an essential part of staying current—getting the lowdown on who's generating the work, who's getting the work and what it takes to maintain a competitive edge.

Networking also provides an opportunity to catch up on how other professionals are dealing with software and hardware upgrades as well as other technological advances. Technology is having such a dramatic impact on the graphic arts industry that trade practices are changing on a monthly, even weekly, basis. It's imperative that you keep in touch with other professionals who can help you understand and work through the changes that come about with every technological advance.

Don't forget meetings and conferences. If you've never been involved in professional organizations, now is the time to attend meetings of your local art directors club, ad club or AIGA chapter. These offer some of the best networking opportunities available. You might even find it worthwhile to become actively involved in these organizations by volunteering your time or expertise. You'll find that opportunities for interaction with other creative professionals are much more meaningful and productive when you work by yourself.

If networking doesn't satisfy your need for interaction, you may miss the feedback you get from working with others. If that's the case, consider partnering with another professional in a similar situation so you can collaborate on projects. If your volume of business warrants it, consider bringing in some freelance help.

Gain Recognition Through Achievement

One of the best ways to gain recognition is through winning competitions. Local ad agencies and art directors clubs often sponsor competitions that bring recognition to designers and illustrators by exhibiting their award-winning work. In addition to having the opportunity to display your work, you can also reap the benefits of the high visibility and networking that come from attending awards ceremonies.

Creative professionals are always impressed by colleagues who attain the high level of recognition from winning national competitions. Many of these competitions are sponsored by trade magazines that feature awardwinning work in a special issue. Other organizations showcase award-winning work in bound books known as awards annuals. Here's a list of some of the most well-known and highly respected national design, illustration and advertising competitions:

AIGA Communication Graphics

Awards are given for every facet of communication design, including all aspects of print (except for books and book covers) and packaging as well as interactive multimedia. Winners are featured in the annual *Graphic Design USA*.

Contact American Institute of Graphic Arts, 164 Fifth Ave., New York, NY 10010. Phone (212) 807-1990, ext. 231. Web site: www.aiga.org.

American Advertising Awards, or Addys

Recognizes excellence in advertising.

Contact The American Advertising Federation, 1101 Vermont Ave., N.W., Suite 500, Washington, DC 20005-6306. Phone: (800) 999-2231 or (202) 898-0089. Web site: www.aaf.org.

American Center for Design's 100 Show

Competition selects one hundred pieces that exemplify excellence in significant trends of communication design, including all facets of print, broadcast, interactive multimedia and product design.

Contact American Center for Design, 325 W. Huron St., Suite 711, Chicago, IL 60610. Phone: (312) 787-2018. Web site: www.ac4d.org.

Clio Awards

Recognizes excellence in all areas of advertising, direct marketing, package design and promotional merchandise.

Contact Clio Awards, 200 W. Jackson Blvd., Suite 2700, Chicago, IL 60606. Phone: (800) 946-2546 or (312) 583-5300. Web site: www.clioawards.com.

Communication Arts magazine's *Advertising Annual*, *Design Annual* and *Interactive Design Annual*

Special issues of *Communication Arts* magazine recognize excellence in each of the above disciplines.

Contact *Communication Arts*, P.O. Box 10300, Palo Alto, CA 94303. Phone: (650) 326-6040. Web site: www.commarts.com.

Graphis Annuals

Outstanding work in new media, posters, print advertising, annual reports, brochures, identity and book design is showcased in a series of annuals.

Contact *Graphis*, 141 Lexington Ave., New York, NY 10016. Phone: (212) 532-9387. Web site: www.graphis.com.

HOW International Design Competition and HOW Self-Promotion Competition

Special annual issues of *HOW* magazine feature outstanding design in all areas of print and multimedia and excellence in self-promotion.

Contact *HOW* magazine, 1507 Dana Ave., Cincinnati, OH 45207. Web site: www.howdesign.com.

PRINT's *Digital Design & Illustration Annual* and *PRINT*'s *Regional Design Annual*

Special issues of *PRINT* magazine feature outstanding illustration and design in all facets of print and multimedia.

Contact *PRINT* magazine, 3200 Tower Oaks Blvd., Rockville, MD 20852. Phone: (212) 463-0600. Web site: www.printmag.com.

Society of Illustrators Annual Competition

Competition recognizes excellence in illustration. Winners' work is displayed in an annual exhibition.

Contact Society of Illustrators, 128 E. Sixty-third St., New York, NY 10021. Phone: (800) 746-8738 or (212) 838-2560. Web site: www.societyillustrators.org.

Step-By-Step Graphics Competition

This annual competition honors excellence in thirty-two categories of graphic design, illustration, photography, multimedia and video design. Winners are published in *Step-by-Step Graphics 100* and *Step-by-Step Graphics Illustration Annual*. Fee varies. Deadline is October.

Contact *Step-By-Step Graphics*, 6000 N. Forest Park Dr., Peoria, IL 61614-3592. Phone: (309) 688-2300. Web site: www.dgusa.com.

→ You need not be limited to a two-thousand-dollar annual IRA contribution towards your retirement. When you run your own business, you become eligible for a variety of tax-sheltering opportunities that are offered to business owners. If you incorporate you can even set up a 401(k) plan.

Regardless of whether your business is a sole proprietorship, partnership or corporation, you can set up a pension plan or Keogh account for your retirement. Several different types of plans are available to the self-employed.

* **A Simplified Employee Pension** (SEP) is one of the easiest plans to set up. It allows you to contribute up to 13 percent of your net income and up to thirty thousand dollars annually. You may set up your SEP and make contributions as late as April of the year following the year in which you'll deduct them.

* **Keogh, pension or profit-sharing plans** offer greater tax deductions, but they involve more paperwork than a SEP. You must set up these plans by December 31 of the year for which you claim the contributions. Here is more specific information on these other types of plans:

* **Money purchase pension plans** (MPPPs) allow you to contribute 20 percent, or up to three thousand dollars a year. When you set up an MPPP, you designate the percentage of your income you'll put in each year and stick to it.

* **Profit sharing plans** are similar to MPPPs, letting you save up to 13.04 percent or thirty thousand dollars annually. The amount you contribute can vary from year to year. This plan might be right for you if your income is not consistent.

* **Defined benefit plans** are established by having an actuary calculate how much you must contribute annually in order to receive, after you retire, the amount you specify. You could conceivably contribute 100 percent of your income. Because this plan is costly to set up, it's recommended only for those who have a high income level and are close to retirement.

Seek professional advice from a certified financial planner to determine what works best for you.

CASE STUDY | ## Designer–Photographer Adapts to Changing Times

"I REALLY LOVE COMPUTERS. THEY'VE ALWAYS BEEN A PART OF MY LIFE," SAYS JANE LINDLEY OF SUPER WEBGIRL. AFTER WORKING AS AN EDITOR, GRAPHIC designer and photographer, Lindley is now capitalizing on her love of computers, riding the wave of success that's come to those who do Web site design.

Lindley works from an office in her home on Bainbridge Island in Puget Sound, a thirty-minute ferryboat ride from Seattle. Her latest venture is the third in a string of businesses she's been involved with since moving from Boston to the Seattle area in 1992. Since then, she's worked mostly from her home. "When I moved to Seattle, I started my own photography business," says Lindley, who initially operated from her home. But as her clientele grew to include Adobe, Aris and other Seattle-based high-tech firms, she moved into rented studio space.

After three years of success as a photographer, Lindley wasn't totally satisfied. "I started to get the itch to do some computer work," she explains. In 1995, Lindley decided to partner with graphic designer Mary Eaton—forming Lindley Eaton Productions—and get involved in photography and graphic design. At that point, Lindley moved her work out of her rented studio and back into her home, and Lindley Eaton became what Lindley calls a "virtual office." Says Lindley, "We would meet at her place or mine and break the job down. Then she would do part of it and I would do part of it."

Although Lindley Eaton Productions was doing well, Lindley became intrigued with the interactivity of the Web. After teaching herself HTML coding, Lindley started doing Web site design for clients independent of Lindley Eaton Productions. The more she got involved, the more the demand for her expertise in this area increased.

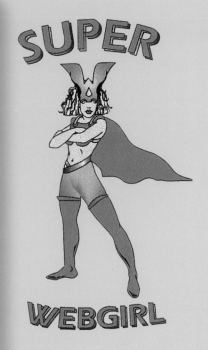

"*A lot of the clients I'm working with hired me for graphic design, and now I'm working with them on their Web site. My business has sort of grown with them.*"

JANE LINDLEY

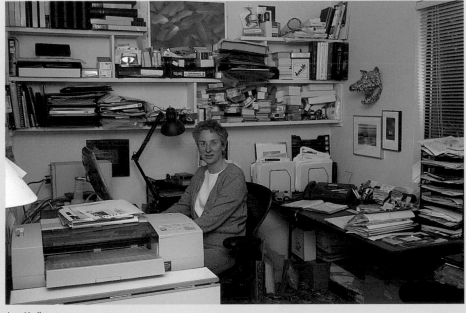

Jane Lindley

Graduating to Web design allowed Lindley to streamline her equipment needs so she can work comfortably in her 8½' x 15' (2.6m x 4.6m) studio. Regarding Web design, Lindley says, "Portability is important. My laptop's been great to take to meetings."

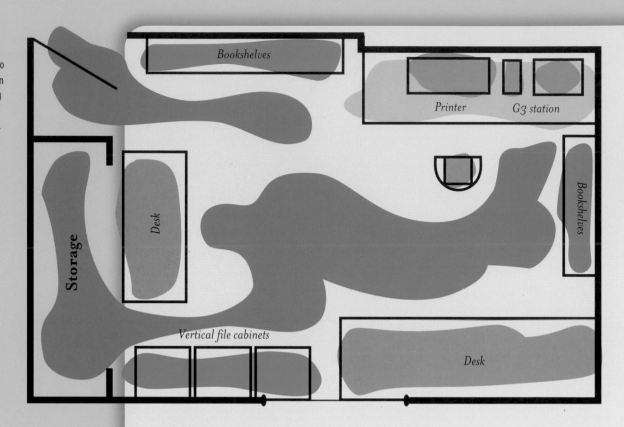

Bookshelves

Printer G3 station

Bookshelves

Storage

Desk

Vertical file cabinets

Desk

In 1999, Lindley Eaton disbanded, and Lindley established Super WebGirl. "Mary wanted to stay in the print world, and I really wanted to do Web sites," Lindley explains. With the perspective of a seasoned entrepreneur, Lindley feels this has been the most lucrative of all her business ventures. "I've just been floored with the response," she states. "I sent out a letter to previous clients and a press release to the local papers. Since then, I've gotten a call every week."

Making the transition from graphic designer and photographer to Web site designer has been an easy one for Lindley. "I had maxed out my [Apple Power] Mac 8100 with 256 MB of RAM and a 6-GB hard drive," says Eaton, who often found herself working with huge Adobe Photoshop files as part of Lindley Eaton Productions. Because Web site design requires low-res files and far less

computer memory, Lindley is able to do her Web site work on an Apple Power Mac G3 laptop, which also gives her the portability she needs for presentations. Her Power Mac 8100 has been relegated to bookkeeping and word processing.

Lindley's transition as a business owner from Lindley Eaton Productions to Super WebGirl was also easy. Because Lindley Eaton was incorporated and in the process of applying for Subchapter S status, Lindley found it would cost her less to reestablish it as a Subchapter S Corporation. After purchasing Eaton's

STUDIO EQUIPMENT

Computers	Apple Power Mac 8100, Apple Power Mac G3
Black-and-White Printer	Hewlett-Packard 4MP
Other	Sony Mavica digital camera, Lacie CD-ROM burner

122

shares of the business for a minimal fee, Lindley was able to file the necessary papers for less than two hundred dollars. "It would have cost me more to close Lindley Eaton Productions and then establish [a new] S corp," she explains.

Lindley wanted to maintain corporate status because she ultimately wants to hire others to help her in her work. Finding space for them to work in her one-bedroom studio won't be a problem. "I think I'm going to be able to hire 'virtual employees,'" she explains. "I've already hired people from Texas and New Mexico to work on Web sites." ⌗

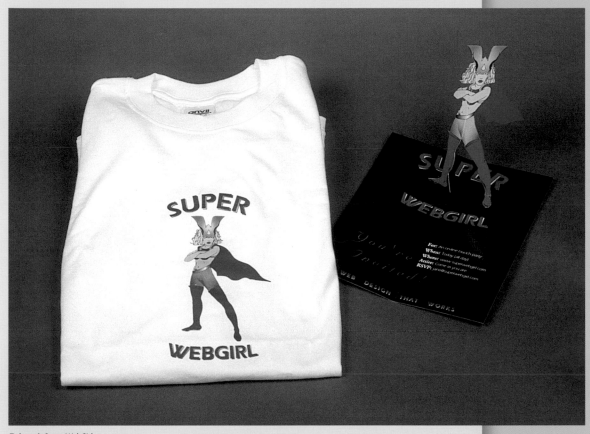

To launch Super WebGirl, Lindley hired a paper technician who helped her design a pop-up invitation to an online launch party. She's also sent out T-shirts printed with her firm's logo. Lindley targeted her mailing to 150 prospective clients, many of them businesses she had worked with in her other ventures.

Since its formation in 1999, Super WebGirl has designed Web sites for a variety of clients. Lindley says much of her current business comes from firms seeking site redesigns. "A lot of people panicked and had anyone throw something up on the Web for them. But they realized that just being on the Web isn't enough. I can come in and create a stronger customer draw to make it more logical," says Lindley.

[Your Perfect Home-Based Studio]

GALLERY

"Unsportsmanlike Conduct"
by Miles Batt

"Except for sleeping, I spend

more time in my studios

than in my home."

MILES BATT

WHEN ARTIST MILES BATT FIRST MOVED TO FLORIDA, HE MADE A LIVING PAINTING SIGNS. WHILE BATT HAS SINCE LEFT THE SIGN BUSINESS, HE HAS continued his career in painting.

Today, Batt works out of two studios in Fort Lauderdale, Florida. His home studio, which is reserved for his fine art work, is shared with his wife, artist Irene Batt. Just down the street is Studio 301, a duplex Batt built several years ago as a place where he could conduct business.

Batt's home studio was designed according to the "function produces form" principle, and thus only the essentials were incorporated into the setting.

Every design choice was made with two prime factors in mind: minimum costs and a contemporary look and feel. "How to keep the studio a separate yet an integral part of the home package became the problem," says Batt. To maximize space, Batt built the library and storage in a loft area. Below the loft, he installed his work space, computer station, meeting room and slide archives.

For locomotion, all cabinetry and equipment is on wheels. Batt stores larger works in a 19' vertical space he made available, while smaller works can be moved throughout the lower level. "Having a well-ordered, functional studio in which to work encourages my creative impulses," Batt says.

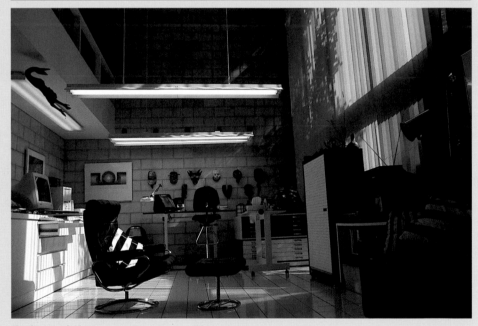

The elements of Miles' studio: a white tile floor, sand-finished block, simple drywall ceilings and a loft with hidden varnished pine stairway.

[Your Perfect Home-Based Studio]

Ten drawer flat file

Homemade roll around

High roll-up cabinet

Low TV stand/books

Sofa

File cabinet

Drafting table

Computer station

Rest room

Wheeled cabinet

Sink

First floor

Open

Storage

Bookshelves

Loft

HOME STUDIO EQUIPMENT

Computer	ACER, 21" monitor
Color Printer	Epson 600
Scanner	UMAX with slide capability and photocopier
Other	Zip drive, CD burner

> *"It's amazing what can be accomplished with black and white spray paint, gray wall paint, some used office furniture from the classified section, Home Depot low-pile carpet and a few select, new art furniture purchases."*

MILES BATT

Storage

Ten drawer flat file

Sofa

Five drawer flat file

Folding table

Folding table

Folding table

Microwave

Rest room

Vertical storage

Flat storage

Fax

Flat storage

Wheel cabinet

Built in desk

Roll-up cabinets

Homemade wheel around

Flat table

Vertical storage

Drafting table

Flat storage

Projection room

Flat shelves

Book shelves

Tall flat file

Framing/presentation easel

Large storage

Mixing table

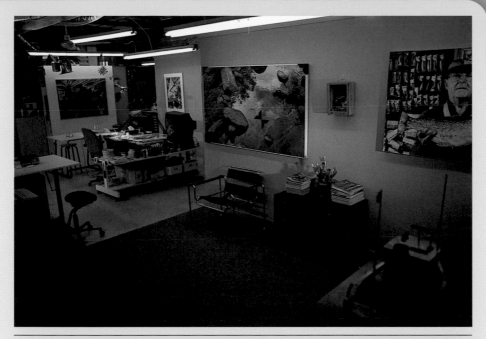

"Bull Mountain" by Miles Batt

STUDIO EQUIPMENT

Computers	Emachine with 17" monitor
Color Printer	Epson 600
Scanner	ACER
Photocopier	Included with scanner

Studio Building Suggestions by Miles Batt

Begin with an empty, stripped room. Then visualize: make a floor plan and walk through it. Leave at least 28" for circulation paths. Build or buy flat table areas for the right and left sides of work areas. Separate areas by the medium you intend to use. Replace clumsy vertical easels with a scaffold easel permanently installed on the longest wall.

Artists can never have too much storage. Store "stuff" in closed cabinets. This not only keeps "stuff" out of sight and in its place, but also eliminates the need to clean and dust "stuff." Search the classified ads under used furniture for flat files, closed door lateral files, drafting tables, and other equipment.

Install wheels on everything possible. They allow for quick studio changes. Invest in simple 8' double fluorescent fixtures for lighting. Mix warm and cool or use Chroma 50 tubes to produce flat but neutral light.

Shelves require some woodworking skills (1" x 12" pine lengths and quality interior latex paint). Don't forget to look in the "mistake" gallon department. Wonderful grays may be mixed with opposing colors. Be sure to buy enough (about 300–350 square feet to a gallon).

Good luck!

MYMRYK & SCORDINO DESIGN ASSOCIATES

"It's nice to be in a neighborhood where you can look outside to see kids playing and people walking their dogs."

PHIL SCORDINO

CAMERON MYMRYK AND PHIL SCORDINO ARE PARTNERS IN THE DESIGN BUSINESS. THEIR STUDIO IS LOCATED at Mymryk's residence in Hamilton, Ontario.

Scordino explains that visitors feel more comfortable and relaxed in the home environment compared to corporate space, where the atmosphere tends to be cold and impersonal.

Just as their clients do, Mymryk and Scordino appreciate their studio's casual work environment. "There's no hustle and bustle of the downtown city district," says Scordino.

Finding creative inspiration right in their backyard, the two designers can take a break relaxing on the patio or taking a walk.

"Security isn't a problem, thanks to our two dogs Loki and Vader, who insist on meeting all visitors," says Scordino.

STUDIO EQUIPMENT

Computers	Apple G3 Towers (2) and an ibook Apple G3 laptop
Color Printer	Epson 1520 Stylus (17" x 22" format)
Black-and-White Printer	Apple LaserWriter II G
Scanner	Microtek ScanMaker VG UPL with Tranay adaptor
Photocopier	Panasonic 11" x 17"
Other	LD writer, Zip, Optical

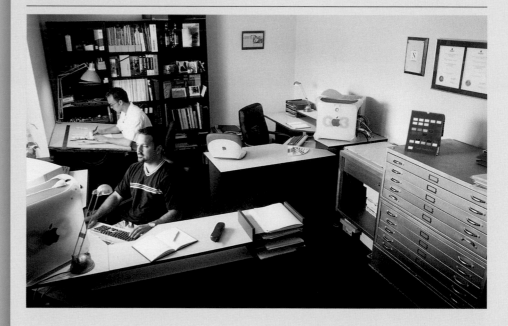

[Your Perfect Home-Based Studio]

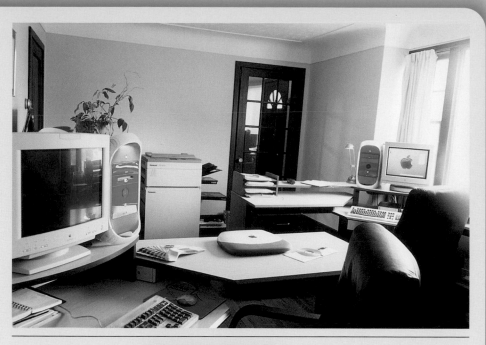

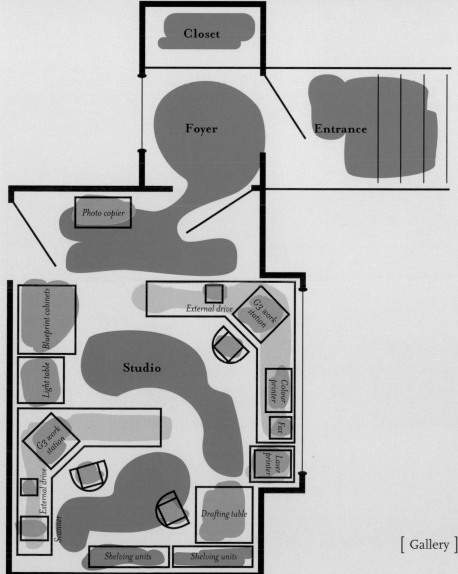

Closet

Foyer

Entrance

Photo copier

Blueprint cabinets

External drive

G3 work station

Light table

Studio

Colour printer

Fax

G3 work station

Laser printer

External drive

Scanner

Drafting table

Shelving units

Shelving units

GALLERY | **Making Sense of Home Business**

"The best part of working at home is the extra time you save by avoiding the commute in traffic every day. And my dog likes it when I'm home with him."

SHAWN HALL

N OT TOO FAR AWAY FROM MYMRYK & SCORDINO IS THE HOME STUDIO OF SHAWN HALL, LOCATED IN TORONTO, ONTARIO. HALL WORKS ALONE, UNLESS OF course you count his American pit bull and an occasional freelancer.

Hall holds home business in high esteem. "I think it's very professional, and I get a certain amount of respect because I'm venturing out on my own. More and more people are going to be working this way."

Hall's studio is fully equipped except for a photocopier. His neighbor, a fashion designer, allows him to use her copier. Hall leases about half his equipment and owns the other half. "Leasing equipment just makes a lot of business sense," he says. "It's easier to pay small amounts over the course of a few years rather than spend a large sum of money up front, especially when you're first starting off on your own." Hall notes that another leasing perk is the opportunity to write those costs off as a business expense.

One final piece of advice from Hall: "Make sure to insure all your office contents. When you work from home, you can take advantage of some great insurance rates."

STUDIO EQUIPMENT

Computers	Apple G3, Apple G4, 21" monitor (2), 5300e laptop
Color Printer	Epson 1200
Black-and-White Printer	MS 860
Scanner	Agfa Duoscan
Other	CD burner, one drafting table and one Olympus digital camera

[Your Perfect Home-Based Studio]

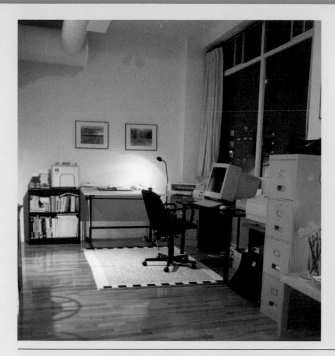
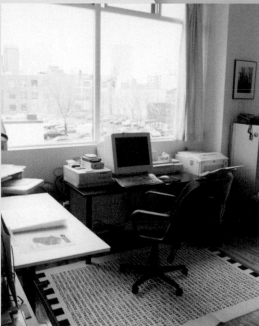

Bedroom

Printer

Work station

Color printer

Fax/ filing cabinet

Couch

Entertainment center

Drafting table

Livingroom/Work Area

Book shelf

Bathroom

Laundry/ Storage

Kitchen

Work station 2

D W T F

> *"I find that I spend less time administrating and pitching work, and more time doing what I love to do."*
>
> KEN WHITMAN

HUSBAND-AND-WIFE TEAM KEN AND SUSAN WHITMAN HAVE BEEN WORKING OUT OF THEIR LOS ANGELES HOME STUDIO FOR SIX YEARS. PRIOR TO THEIR HOME STUDIO, THE DESIGN PARTNERS managed an 11-person staff in a rented $6,000-per-month office space.

"The move to a home studio was a very successful one. We've never looked back," says Ken Whitman. The Whitmans say that it would be hard for them to leave their studio and their lifestyle—despite all the offers they've received to do so.

In their previous studio the Whitmans worked with two designers, two production artists, a receptionist, a partner, a market researcher, an administrator, two print production assistants and a financer.

"Due to the ever-increasing power of computing, we've been able to eliminate functions we had to cover in the 'old' days," Ken Whitman says. "The upside for me is that I get to be hands-on in all the creative work." The Whitmans also discovered that as a two-person team, they can make as much net profit in their home studio business as they had previously made in the large office with the large staff. "It's just a matter of working longer hours with lower overhead."

STUDIO EQUIPMENT

Computers	Power PC 9500/300 MB G4 Newer Tech card 1448 MB RAM; Power PC 9500/150; Powerbook G3 300/192; and Powerbook G3 233
Color Printers	Epson Stylus 1270 and Epson Stylus Pro XL
Black-and-White Printer	Apple LaserWriter Select 360s (2)
Scanner	UMAX Powerlook III
Other	Lacre DVD Ram

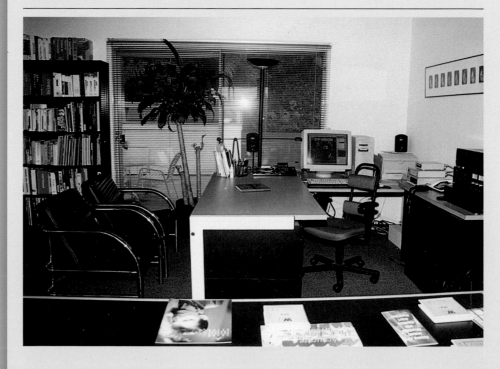

[Your Perfect Home-Based Studio]

A second life: workstations, furniture and storage from the Whitmans' previous office have taken a place in the couple's home studio. Formerly a music studio, the office is located at the back of the house; its dimensions are virtually identical to the firm's prior office space.

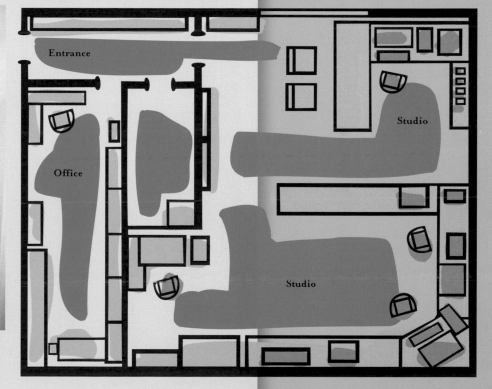

CANDACE CROWE DESIGN

"The personal and family advantages of working at home are what keep me doing it."

CANDACE CROWE

A S A MOTHER AND PROFESSIONAL DESIGNER, CANDACE CROWE RECOGNIZES THAT MAINTAINING BOTH A FAMILY AND GROWING BUSINESS REQUIRES discipline, planning and long hours.

Situated in Orlando, Florida, Crowe's advertising agency is nestled "in the heart of the home," and receives various visitors including vendors, associates and occasional clients. "Although I am sensitive to the children's needs, normal office hours are always respected," says Crowe.

Crowe values the control that a home business allows her regarding her income and schedule. If her company is working on large projects or under pressing deadlines, Crowe's team of independent professionals camps out at her studio until they complete the work.

The staff support includes a junior designer, an intern and Crowe. Additional help comes from Crowe's alliances with independent professionals such as Web programmers, media buyers, electronic finishers, computer technicians and photographers. Not to be forgotten, Crowe also notes the assistance of an accountant, lawyers, after-school help and a housecleaning and yard service.

"Being in the industry of creating images for other companies, it was extremely important for my company to portray a confident image of business and technology savvy," Crowe says.

To achieve that image, Crowe focused on developing three points of public contact: an efficient phone system, specially-branded collateral materials and a professional dress standard.

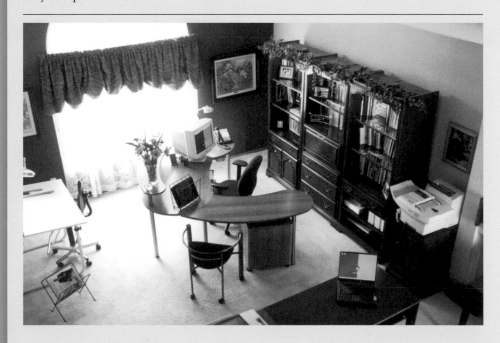

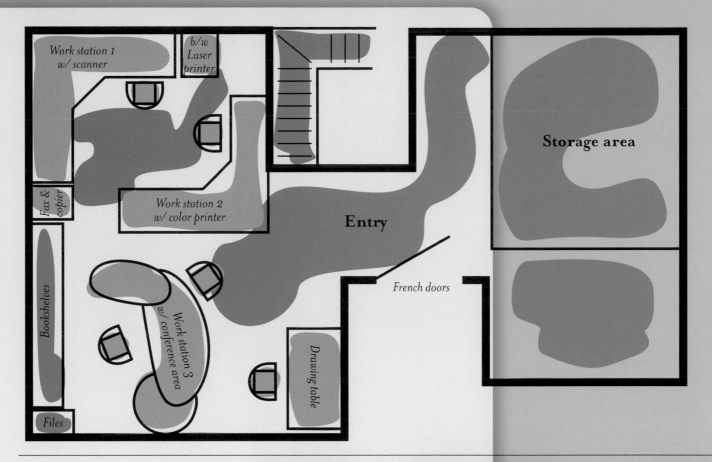

Work station 1
w/ scanner

b/w
Laser
printer

Storage area

Fax &
copier

Work station 2
w/ color printer

Entry

Bookshelves

French doors

Work station 3
w/ conference area

Drawing table

Files

STUDIO EQUIPMENT

Computers	Mac workstations (3) with Internet connection and a Sony VAIO notebook computer (for client presentations)
Color Printer	One large formal printer
Black-and-White Printer	One laser printer
Scanner	Agfa scanner
Photocopier	High capacity office fax and copy machine
Software	Graphic design content creation software tool suites
Phone System	Lucent 4-line phone with extensions and voice mail, and a Nokia cell phone
Other	Credit card terminal, postage meter and Palm Pilot

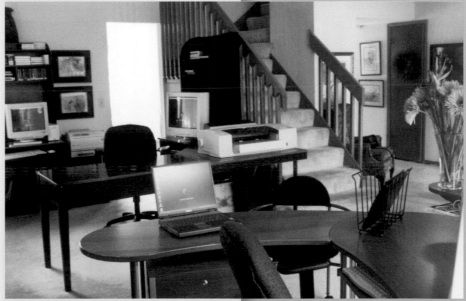

> *"When it comes to studio atmosphere, it's all about personal preference."*
>
> BOBBY JUNE

SOLO DESIGNER BOBBY JUNE WORKS FROM HIS HOME STUDIO IN LONG BEACH, CALIFORNIA. JUNE PERCEIVES THE HOME BUSINESS WORK SCHEDULE AS containing several micro-weekends.

For June, owning a home studio means the freedom to do what you want, when you want. But he also acknowledges the fact that, with a home studio, you will sometimes find yourself working when most other people are not. "But that's okay, because earlier that morning, maybe you were out roller blading for a couple of hours because it was a great day and you felt like it," June says.

June considers organization to be an essential attribute that all home studios should have. "To function on three to five substantial projects simultaneously with two new prospects calling for quotes, you must have your act together," says June.

With that principle in mind, it was important for June to use his home space wisely when building his studio. In the hallway that connects to the studio, June mounted four 2" shelves along each side of the wall. The shelves display June's various design projects, giving visiting clients the opportunity to view some of his work.

Another space saver June suggests is transforming a closet in the studio into a supply/fax room. The following are June's instructions:

"If it has a single door, simply remove it. If it's a sliding door, remove both doors. Purchase a four-panel hinged room divider. Place it in front of the open closet for easy access from both sides while still blocking its primary view. You'll have to find a new spot for your clothes, but at least you won't be getting dressed in the office anymore."

Finally, June advises studio owners to add personal touches: non-graphic design art work that you've created; fun, quirky details or items describing you; several windows; candles; and good business books about marketing and design.

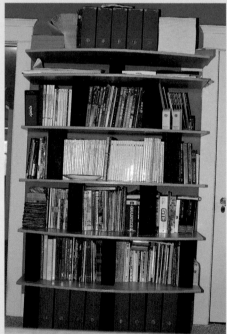

June designed and constructed custom storage units out of blonde wood to complement the soft hue of the studio's sage-green walls.

STUDIO EQUIPMENT

Computers	Mac G3 400 and Mac G3 Powerbook
Color Printer	Epson 1520 (large format)
Black-and-White Printer	HP Laser Jet 4MP
Scanner	UMAX 1260 Flatbed and Polaroid Sprint scan slide scanner
Copier	Brother copier
Other	Jaz, Zip drive, CDRW, 8-port Asante 10/100 HUB, 1.5/1.5 DSL, Nikon Cool Pix 950 digital camera, APS power back-up, Siemens phone system, computer/stereo speaker system

Although June's office is located in a small bedroom, he also uses other rooms throughout the house for work. He meets with clients in the living room or around the dining-room table, where he periodically serves lunch.

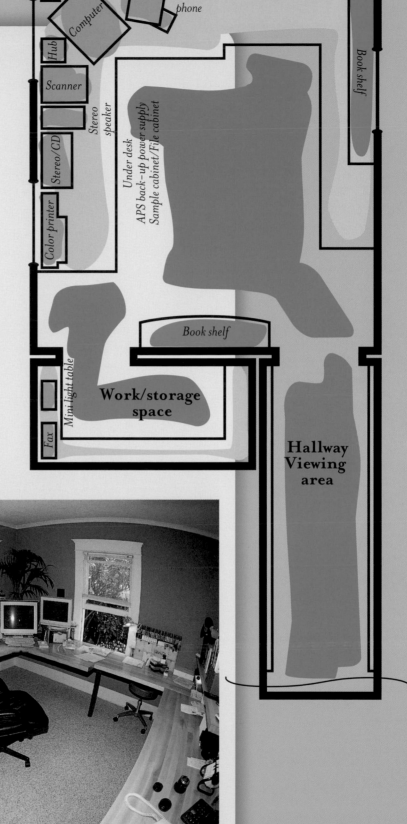

Bass

Computer

Monitor/phone

Project organizer

Hub

Scanner

Book shelf

Stereo speaker

Stereo/CD

Under desk
APS back-up power supply
Sample cabinet/File cabinet

Color printer

Book shelf

Mini light table

Work/storage space

Fax

Hallway Viewing area

GALLERY | **Mastering the Art of Multi-Workstations**

"Sharing a studio is a natural

for our entire family."

KAREN BERGER

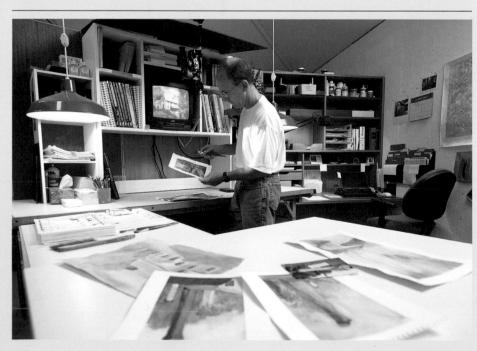

Charlie Berger video-records personal critiques of his students' artwork.

I N SOME CASES, A HOME BUSINESS LIFESTYLE REQUIRES FAMILY MEMBERS TO SHARE THEIR WORK SPACE. AS BOTH PROFESSIONAL ARTISTS AND PARENTS OF A 4-YEAR-old daughter, husband and wife Charlie and Karen Berger have discovered joy and success in this challenge.

Charlie and Karen each manage their own home business. Charlie runs Master Class Studios, a fine art teaching program that offers video critique services allowing students to learn at home. Karen runs Signed Sealed Delivered, a graphic design company offering services ranging from custom birth announcements to CD cover design.

Literally speaking, the Bergers go to work in their own backyard. Several years ago the couple converted their garage—a separate unit behind their house—into a studio. At one time, it served as an art studio for their drawing, sculpture and glass business, One by Two. Today, operating under companies independent of each other, the Bergers have divided the studio into separate workstations sufficient for their individual tasks.

The Bergers keep busy juggling project deadlines while sharing studio space with their daughter, Mason. "There are times when we're all working on separate projects, and then there are times when Mason is sitting on my lap as I read a book to her while dad is finishing up a critique," Karen Berger says.

The Bergers have dedicated a part of the studio to a child-fit workstation that suits Mason's special tasks at hand, with her own penchant for art in tow.

"We all know how stressful it can be to sit at a desk for hours trying to satisfy a demanding client and a tight deadline," says Karen Berger. "Then our daughter may run in breathless, all excited about something as simple as a banana popsicle. Sometimes it's an interruption, but in the larger picture it's a welcome distraction. She comes in about the time you most need a reminder of what's really important."

140

[Your Perfect Home-Based Studio]

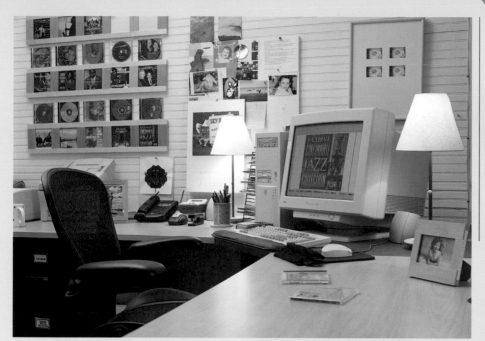

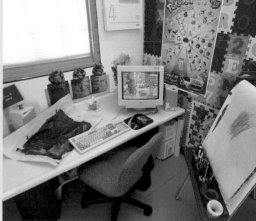

The office of 4-year-old aspiring artist (or is it designer?) Mason Berger.

Karen Berger's design work includes the CD covers on display above her desk.

STUDIO EQUIPMENT

Computers	(PC) Pentium 3 500 with 256 MB RAM; (PC) AMD K6-500 with 128 MB RAM; (PC) Pentium 166 with 64 MB RAM (child's computer)
Color Printer	Epson 3000 (large format ink jet)
Black-and-White Printer	HP LaserJet 2100 TN
Scanner	Microtek Scanmaker 5
Other	Standalone fax machine (Canon Fax Phone)

Brenda Walton Studio
Brenda Walton
P.O. Box 161978
Sacramento, CA 95816
Phone: (916) 452-8977
Fax: (916) 452-8978
Web site: www.brendawalton.com

Candace Crowe Design
Candace Crowe
3474 Hillmont Circle
Orlando, FL 32817-2071
Phone: (407) 671-7828
Fax: (407) 671-1466
E-mail: Candace@e-ccd.com

ideation Design
Shawn Hall
80 Sherbourne St. #309
Toronto, Ontario MSA 2R1
Canada
Phone: (416) 706-4355
Fax: (416) 706-2674
E-mail: Hall2@idirect.com

Mark Andresen Illustration
Mark Andresen
6417 Gladys St.
Metairie, LA 70003
Phone/fax: (504) 888-1644
E-mail: andresenm@aol.com

Modern Design
Stephanie Redman
P.O. Box 721652
Newport, KY 41071
Phone: (859) 331-7724
Fax: (859) 331-7729
E-mail: moderndesign@fuse.net

**Mymryk & Scordino Design
 Associates**
Cameron Mymryk and Phil Scordino
313 Stanley Ave.
Hamilton, Ontario L8P 2L7
Canada
Phone: (905) 540-1522
Fax: (905) 540-8991

9Volt Visuals
Bobby June
231 Euclid Ave.
Long Beach, CA 90803
Phone: (562) 987-1288
Fax: (562) 987-1469
E-mail: INFO:@9VOLTVISUALS.com

Studio 301
Miles G. Batt, Sr.
301 Riverland Rd.
Ft. Lauderdale, FL 33312
Phone/Fax: (954) 583-9207
E-mail: milesbatt@aol.com
E-mail: ideas@msdesign.on.ca

Super WebGirl, Inc.
Jane Lindley
P.O. Box 10765
Bainbridge Island, WA 98110
Phone/fax: (206) 842-2983
Web site: www.superwebgirl.com

Thompson Studio
George and Emily Thompson
5440 Old Easton Rd.
Doylestown, PA 18901
Phone/fax: (215) 766-3892
E-mail: emilyt@idt.net and
 gthompsonpa@earthlink.net

TP Design, Inc.
Charly Palmer and Stephanie Taylor
7007 Eagle Watch Ct.
Stone Mountain, GA 30087
Phone/fax: (770) 413-0276

Treehouse Design
Tricia Rauen
10627 Youngworth Rd.
Culver City, CA 90230
Phone: (310) 204-2409
Fax: (310) 204-2517
E-mail: tr_treehouse@pacbell.net

Tucat Studio, Inc.
Robin Moro
1228 Neale Rd.
Loveland, Ohio 45140
Phone: (513) 677-2526
Fax: (513) 677-9408
E-mail: tucat@earthlink.net

Whitman-Hall Design
Ken Whitman & Susan Hall-Whitman
2200 Brier Ave.
Los Angeles, CA 90039
Phone/fax: (323) 665-0144
E-mail: Ken@Whitman-Hall.com and
 Susan@Whitman-Hall.com

Woman on the Verge
Renee Kuci
14050 Farmer Rd.
Miami, FL 33158
Phone: (305) 254-9350
Fax: (786) 242-6024

Xeno Design
Chris and Patti Garland
6901 Mammoth Ave.
Van Nuys, CA 91405
Phone: (818) 782-4197
Fax: (818) 787-5668
Web site: www.xenodesign.com

Permissions

index